A LOVE STORY THAT TRANSCENDS DEATH

Signs of Alan

Doris Gray

Divine Guidance Press, LLC
Boulder, CO

GAYLE & ROB,
MAY YOU BE BLESSED
WITH MUCH LOVE, JOY,
& PEACE.

Published by
Divine Guidance Press, LLC
P.O. Box 17063, Boulder, CO 80308

Books may be purchased for individual or group promotion by calling the author at 303-438-5572 or by directing an e-mail to doris@signsofalan.com.

Cover and interior design by Nick Zelinger, NZ Graphics
Editing by Melanie Mulhall, Dragonheart Writing and Editing
Cover photograph by Paul Adkins
Author photograph by Beth Adkins
Alan Gray photograph courtesy of Eric and Dawn Keller

Printed in the United States of America

First Edition

ISBN 978-0-9824907-0-9
Library of Congress Control Number: 2009929656

In Loving Memory of My Husband,
Alan Richard Gray

November 12, 1946 to March 28, 2002

Table of Contents

Acknowledgements

Most importantly, I thank God for inspiring me to share the experiences in this book.

Unsure of my direction after leaving my corporate position in 2003, I beseeched God, *What is my purpose?*

I heard that still, small voice say, *Write.*

As a result, God has been instrumental in transforming me from a strong, successful businesswoman into the softer, creative woman I am today and one who is increasingly open to—and aware of—God's love and the spiritual gifts available to me through my faith.

In addition, I am deeply grateful for the consistent love and support shown to me by my grown children, Jamee, Beth, Sarah and Paul. They were there for me when I needed them most, following Alan's fatal accident. I will forever treasure their frequent phone calls and their sincere love and empathy. My heart has been touched, as well, by the pure, innocent insights of my grandchildren.

Sarah and her son, Mitchel, lived with Alan and me for the six years prior to Alan's passing. Sarah knew Alan better than any of my other children, sharing deeply in the loss. Likewise, she witnessed many of the signs or coincidences mentioned in this book, often declaring, "Mom, are you keeping track? Write that down!"

Three years after Alan died, I was experiencing withdrawal from the structure provided by the corporate environment and suggested to Sarah that, perhaps, I should get a part-time job. Candidly, she exclaimed, "Make writing your job!" That declaration was exactly the boost I needed. Six weeks later I had completed the first draft of this book.

Thanks to my many friends including, but not limited to, Donna Baase, Laura Bullock, Jayne Cooper, Laura DalPiaz, Jennifer Evans, Lori Francin, Donna Gail, Pete and Marilyn Hasselriis, Eileen Huff, Dr. Nancy Leslie, Carla Sanchez, Deb Scheller, Jackson Webb, and Diane Wilson. These wonderful people provided encouragement as I ventured into writing and publishing this book.

In addition, I want to thank my editor, Melanie Mulhall, for taking me by the hand and walking me through the editing process. Her high level of energy and optimism were inspiring. Thanks, Melanie, for believing in me and my work.

Thank you to my good friends, Jill Stargardt and David Clark, for taking the time to proofread the manuscript "one last time" prior to printing. And finally to Ashi, thank you for sharing your own journey and offering me guidance in the process of self-publishing.

Introduction

Without God in my life, I do not know where I would be today. Perhaps I would be among the dead: either walking the earth emotionally and spiritually obstructed or in a grave. Although I have a religious background—Methodist and Presbyterian during my childhood and, later, Baptist—I am more spiritual than religious at this point in my life. Since losing Alan, my faith has reached a greater depth and a broader dimension, and it is faith that carries me through each day.

Alan and I were married eight years when the accident occurred that took his life. The brutal trauma, the suddenness of his passing, and the ensuing agonizing pain were staggering, overwhelming. As bizarre as it may seem, the abundant blessings were overwhelming, as well.

I believe God lifted me to a higher spiritual plane when I first learned of the accident, and I was held captive in the moment. My senses were extraordinarily heightened. It seemed as though I was observing God's hand at work everywhere, around the accident and throughout the grieving process.

Whether sent from God or from Alan, there have been a myriad of signs—mysterious coincidences—that have brought me peace and comfort. Shortly after the accident, a friend told me there are no coincidences

without meaning, that God is the coordinator of coincidence. If this is true, Alan's accident was no coincidence. Believing that Alan left this earth in accordance with the master plan somehow gives me assurance that all is well.

Though years have passed now, the spiritual depth and the higher level of consciousness I have gained continue to influence my life. No longer do I shake off concurring events as simply coincidence. Instead, I pay attention, open to the connection, and take it as a sign from God or Alan, feeling reassured that I am being watched over and guided in my daily endeavors.

Part I of this book contains a simple explanation of the accident that took Alan's life and some of the circumstances surrounding it.

In my attempt to lay the foundation of my relationship with Alan in Part II, there were many descriptive words that came to mind but no words that could be strung together as sentences or paragraphs, really. How could I begin to define the wonder of Alan and the love we shared? Ending a ten-day period of writer's block, an alternative approach came to light: I would write a love letter. Then the words flowed.

Part III contains the stories of the coincidences that occurred in connection with Alan's passing. These stories often tie experiences we shared before his death with the mysterious occurrences afterward. The coincidences, or signs, came through in various forms, including

material objects, phantom apparitions, someone's words, electrical signals, and that still, small voice of God.

Throughout the process of publishing *Signs of Alan*, I've been asked by my peers "What is your target market?" and "Do you have a business plan?" While I believe this book may not be for everyone, it can be for anyone—male and female, young and old, and widowed, single or divorced. It is a love story and I believe that we are all, regardless of gender, age and marital status, interested in love: the greatest gift.

In conversations with individuals who have lost loved ones—even pets, I've learned that many have experienced one or more signs from those that have passed away. That being the case, most people will not find my experiences surprising. Others may become more mindful of their surroundings and begin to recognize the serendipity in their own lives.

For me, it's about faith. God inspired me to write this book. I was the vessel. In keeping with this truth, I am confident that God will guide me in the distribution of it, as well.

May you be blessed and uplifted as you read *Signs of Alan*.

Part I:
The Accident

As a well-spent day brings happy sleep,
so life well-used brings happy death.
~ Leonardo da Vinci

The accident that claimed Alan's life occurred at approximately 2:15 p.m. on March 28, 2002, a bright and balmy spring day. At fifty-five, Alan had been a spirited, healthy, and vital man, six feet tall and 210 pounds.

Just moments before the accident occurred, Alan had been heading home on his Harley-Davidson motorcycle, traveling east on 120th Avenue in Westminster, Colorado. The right thru lane was used as a turn lane at Zuni Street, one entrance into the suburban development where we lived. As he approached that intersection, Alan moved from the center lane into the far right lane, preparing to turn onto Zuni Street.

Joshua, a sixteen-year-old high school junior, was also heading east in the right lane. Joshua saw Alan ease the motorcycle in front of his car and begin to slow down. Then Joshua sped up in anticipation of passing Alan. As he began to edge into the center lane, Joshua glanced over his left shoulder and observed an SUV, also picking up speed. Joshua was unable to merge into the center lane and instinctively swung back into the right lane. His car collided with the motorcycle at the intersection as Alan readied to make his turn.

Upon impact, the airbags inflated and Joshua was

unable to see what had happened. He lost control in the panic and confusion and his car lurched forward another hundred feet, jumping the southeast curb and dragging Alan under it. The right front tire had blown, causing the front end of the car to come to rest on Alan's hip and abdomen.

The ground emergency medical team arrived within minutes and quickly lifted the weight off of Alan's body. He slipped into unconsciousness as they placed him on the board and into the ambulance. Alan did not survive long enough to be airlifted by the Flight for Life helicopter that had arrived moments earlier. Cause of death: internal injuries.

Although he had truly enjoyed his Harley, Alan had not been obsessive about it. His life was balanced with work and time spent with family and friends. A couple of weeks before the accident, however, Alan said proudly, "At times, when my life seems the least bit mundane, I remind myself that I've got a Harley sitting out there in the garage."

In general, most people think motorcycles are risky. If I had pleaded that he not purchase the bike, Alan most likely would have acquiesced. But Alan loved life and lived each day to the fullest without fear. He was not

a daredevil. He simply followed his heart and enjoyed himself. Alan loved the ride.

In August 2003, this came to light for me in an *AARP, The Magazine* article about baby boomers and their enthusiasm for Harleys. Elinor Nauen, the writer, tried to capture just what is so alluring about owning and riding a Harley through the words of rookies and lifers. Among other things, she learned that if you have to ask what is so appealing about it, you would not understand.

Alan's response to an event that happened shortly before his death is telling about his feelings as a Harley rider, as well as his feelings about what it means to be a human being. Approximately one week before the accident, a six-year-old girl was killed when hit in the head by a spiraling hockey puck at a Colorado Avalanche game in Denver. Upon hearing about the tragedy, my daughter, Sarah, declared, "Her family should sue the team!"

Pragmatic, Alan calmly replied, "No, no. Her family made a choice to attend the game. They took that risk."

Alan chose to take a ride on March 28, 2002. He could not have predicted the outcome. If it was his time to leave this earth, he could have died in many other ways. I am thankful he left quickly and went out doing something he loved—riding his Harley. I am sure Alan would agree.

Joshua was charged with reckless driving resulting in death and he entered a guilty plea at the hearing. The judge sentenced him to five hundred hours of community service. It took Joshua two years to satisfy that requirement. He was a high school senior during the first year. In addition, a judgment for the cost of the funeral and burial was entered against him. He immediately began making small monthly payments to me.

I have never harbored bitterness or anger toward Joshua. Initially, I was numb and generally apathetic toward him. However, I knew that he had not set out to take Alan's life that day.

After one year, I checked in with Joshua's probation officer regarding the fulfillment of his community service hours. The officer told me Joshua had been having a difficult time dealing with the accident, and that he had had to extend the completion date by a few months.

It is my prayer that Joshua will heal and come to understand that there are no coincidences, that the accident was part of the master plan.

Part II:
A Love Letter

I think not how sad it is that you are gone,
but rather how empty it would have been
had you never come.
~ Anonymous

March 14, 2005

Dear Alan,

Soon it will be three years since the accident. That dreadful moment when I learned of your passing was the most painful reality I have endured. Life for me would never be the same.

Who knew it was possible to carry on without you? Not me. For a long time, I didn't want to make the effort.

I remember thinking, *I am not in my body. It is too painful for me there.*

For days, weeks and months on end, I was paralyzed with grief, barely going through the motions of living. Many, many times that first year after you left, blinded by tears in moments of profound desperation, I envisioned driving off a cliff and ending my life. There are many cliffs in Colorado, many options. What stopped me? I don't know.

I tried to hold onto the essence of you. I moved to your side of the bed in an attempt to reduce the void there. For several weeks, I slept with your clothes, the jeans and t-shirt you left lying on the bed that fateful day. Rolled up, they served as my pillow, your familiar masculine scent helping me drift off to sleep each night.

21

I left your Reeboks sitting where you left them in the family room for at least six months. I kept thinking, *Alan will be home soon and he will be looking for these.*

Slowly, one day at a time, I have climbed out of the depths of darkness and despair to find some level of joy again. Now I revel in the wonder of having experienced you in my life. The human spirit is amazingly resilient if we allow it to be, isn't it? You should know. You modeled the way.

Was it destiny? When we met in August 1991, you were 44 and had been widowed one year. I was 42 and had been divorced six years. You had no children and I had four: Jamee (20), Beth (18), Sarah (16) and Paul (15). We lived within five miles of each other in the far west suburban area of Chicago. Although meeting through the personal ads section of a local newspaper was somewhat controversial at the time, we both considered that medium as simply one way to meet someone of the opposite sex. It is unlikely that we would have met under any other circumstances.

Alan, you were a gift from God. Soon after our meeting, my heart was filled with love and admiration for you. The depth of your devotion for—and your steadfast commitment to—your first wife, Nancy, was a testament to the strength of your character. Self-effacing, you talked at length during our first several dates, sharing what it was like for you and for her

throughout the twelve years she was ill. As Nancy's health slowly deteriorated after the brain tumor was irradiated, you sacrificed to fulfill the promise you made when you married her: in sickness and in health, until death do us part. I listened intently and learned much about you—the man, the husband, the gift.

Your adventurous spirit also held me in awe. When we first met, you were training for an extensive trek in the Himalayan Mountains. To prepare, you went to an aerobics class three nights a week and bicycled and hiked several miles on the weekends. You were surprised by my willingness to join you in some of your weekend training efforts. Those long hikes gave us an opportunity to learn about each other and to form a friendship that provided a solid foundation for what would eventually evolve between us.

One Saturday, we bicycled on the trail that follows Lake Shore Drive and Lake Michigan in downtown Chicago. You were patient with me and my rusty riding skills. At the end of the ride, you asked where we should lay out the picnic lunch you had packed. Though I didn't say it, I was astonished and impressed at your thoughtfulness.

You wanted to get out of the city and drove more than an hour west to a park located in a small farming community. There we enjoyed the wine, pasta salad and grapes that you had brought. It was a simple pleasure.

Consistently throughout my adult life, I had provided for and served others, always being the strong and capable one. There you were, treating me like someone special—like a queen.

Before you picked me up for our sixth date, it dawned on me that we had not shared any form of affection. I had noticed that you seemed to talk fast when you walked me to the door after each date, as if you were nervous. You probably were.

That night, as we stood at my front door, I reached out and slipped my arms around your midsection. You graciously welcomed me with your warm embrace, held me close and said, "Thank you. It's been a really long time."

Spontaneously, you placed your lips on mine and held them in a tender kiss before we said goodnight. On the other side of the door, my knees almost went out from under me as I fanned my face with my hand. It had been a really long time for me, too—a lifetime it seemed.

Alan, among the men in my life, you were unique. You were unlike my critical father, unlike the high school boys who seemed to want only one thing, and unlike my manipulative first husband. Fortunately, I was prepared to receive and to value someone like you in my life. Did you know that I had not experienced nonsexual touch before you came into my life? Your

tender affection, without expectation, helped me be-
come more comfortable in my own skin. *Finally*, I was
being accepted and respected.

You were an upstanding man. You honored women
and showed it in many ways, like never failing to open
the car door for me. In the beginning, I felt clumsy and
uncomfortable accepting your kindnesses. But I soon
adapted. You also honored me and my children by not
expecting to spend the night in my home. You said you
could not have faced them in the morning. Did you
think I would have allowed you to stay over? No. Not
only did I appreciate you for respecting me and my
children, I admired your self-respect.

Four months into our dating relationship, you joined
me and my family for Christmas Eve dinner. Secretly,
I hoped you would avoid bringing an obligatory gift,
one that, based on my experience, I probably would
not like. For you, I had chosen a cream-colored
sweater and a beard trimmer. When you came to the
door empty-handed, I was relieved. However, after
we all had exchanged gifts, you went to the coat closet
to retrieve an envelope from your jacket pocket. I quickly
jumped to the conclusion that it was a gift certificate from
a department store, a no-brainer gift. Instead, you sur-
prised me with a gift certificate for a mile-high glider
ride—something you knew I would appreciate.

He gets me, I quickly surmised.

Over the years, you continued to amaze me with your quiet confidence, your insights, and your thoughtfulness—all of which were more important to me than the monetary value of any gift.

In February 1992, six months after we began dating, you panicked when I asked where I stood with you. You assumed that I was asking you for a lifetime commitment. In turn, your reaction frightened me and I failed to explain myself. Looking back, I'm not sure why I asked and how I expected you to respond. In any case, the conversation quickly spiraled downward from there. We decided to take what was intended to be a three-month break. Instead, we reunited after three weeks.

Over the course of that break, I realized that all I had wanted was to know if we were exclusive. Thank God, you were open and willing to talk about it when I approached you. You told me you were not seeing anyone else, and we each admitted that we had been missing the other. You confessed to having tried to detect my essence—White Shoulders—on the passenger seat of your car. You cried openly and told me you feared loving again. I understood. You didn't want to lose another wife. Then I told you that no matter what, I was willing to move forward, taking one step at a time without knowing what the future held. Essentially, I was agreeing to be patient, a virtue I did not know I possessed and one that would be tested.

Shortly thereafter, you announced that you were putting your house on the market and moving to Boulder, Colorado, a dream you had shared with me from the beginning. The economy was in a downturn, negatively impacting the company you represented and, as a result, affecting your income. It seemed the right time for you to make a move. You planned to live with your brother, Rob, and his family until you found work there. Your home went under contract for the full asking price within three days of its listing.

Alarmed, I questioned myself.

What was I thinking when I committed to taking things one step at a time? He will be living 1,000 miles away! What now?

I would uphold that promise. If "we" were meant to be, it would all come together. If not, it wouldn't. It was in God's hands and time would tell.

Spending as much time together as we could during those final weeks you were in Illinois yielded a closer bond between us. You were there for me, thankfully, when my mother died that April, shortly before your move. At the visitation, I pointed out the male relative who had sexually molested me as a young girl. Although you were not the violent type, you phoned me later that night and said, "I wanted to punch him in the face." That comment touched a chord deep within my heart. No one had ever come to my defense about that traumatic experience.

You left in May. Your decision to move was bitter-sweet for me. I was sad, anticipating how much I would miss you. But I was also excited for you and proud of you for following your dream. You were walking the talk.

A few weeks after you arrived in Boulder, you phoned and invited me to come for a visit. You would be house-sitting for your brother's neighbor in July. I offered to come for one week. You encouraged me to stay for two. However, you made it clear that the invitation should not be construed as a commitment. I was apprehensive at first but ventured to Colorado with only one expectation—to enjoy time with you.

And that I did. Every day, we either hiked a mountain or biked on the Boulder Creek Path. Happily exhausted each evening, we planned the activity for the following day. At the end of the two weeks, you were pleased that I had acclimated to the higher elevation and reached the top of Quandary Peak, one of Colorado's 14,000-foot mountains.

I had expressed my love for you early on and in my letters without hope or agenda. Though you had not reciprocated in words, your behavior spoke volumes. You were consistently kind and loving. I sensed that you were not the type of guy who would say those words until you were fully prepared to make a commitment, and I admired you for it.

On my final day in Boulder, we hiked Bear Peak, an 8,461-foot mountain situated on the southwest side of

the city. In the ninety-degree heat, we quickly depleted the one water bottle we had brought with us. When we began our hike, you thought we would be back at the car before noon. At 4:00 p.m., having lost the trail, we resorted to bushwhacking and boulder hopping our way down the mountain.

Dehydrated, weary and cranky, I surprised myself and you by cursing, "Fuck this! Get me off this fucking mountain!"

Patiently waiting for me a short distance down the mountain, you looked up and shouted, "I love you!"

I was struck silent and thought to myself, *He loves me.*

It would be another year before I heard those words from you again, but it was worth the wait.

Over the next several months, you actively searched for work in the industrial pump business, finding it more difficult than you had anticipated. We continued to communicate through letters and, occasionally, by phone.

You wrapped trips to Chicago around out-of-state job interviews. I was always delighted to see you. One of those trips brought you to Chicago over Memorial Day weekend 1993. As usual, we had a nice time together, but I was feeling somewhat disenchanted about our future. You had been in Colorado one full year. When I asked you what your thoughts were on the subject of a future together, you reacted—but not to my satisfaction.

You stood up, turned away, and said you couldn't talk about it. Not wanting to instigate a full-fledged fight, I didn't push for clarification. But your reaction left its mark on me. It seemed you had put up a brick wall regarding the subject. I would have to accept that or move on. When you departed for Colorado, I was more apathetic than sad.

Within days, two job opportunities came together for you, one in Colorado and one in Virginia. You called me almost daily as you contemplated a strategy to work the opportunity in Virginia against the one based in Colorado. You wanted to make your home in Colorado. After all, this had been your dream. Having been unemployed for more than a year, though, you were open to relocating to Virginia if necessary.

You included a copy of your personal financial statement in one of the letters you sent me during that time. Up to that point, we had not discussed our respective finances. Stunned, I wondered if you thought I was going to disclose my financial information. Though I had an excellent credit record, my finances were not necessarily pretty. I thought, *My financial situation is my business. Period.*

You telephoned the first week of June and excitedly shared your good news. You had accepted the position of Northwest Regional Manager for Robbins & Meyers, a pump manufacturer based in Springfield, Ohio.

You would be based in Colorado, traveling fifty percent of the time to Nevada, Wyoming, Montana, Utah, Washington, Oregon and Alaska. Then you asked if I would be available the weekend of June 18-20, as you had to report for job training in Chicago on the 17th and 18th. While not overly enthused, I assured you I would be home. I told you that Sarah was graduating from high school and invited you to her graduation party on the 20th.

You accepted. Then you said, "I'll help you prepare for the party, and we can talk about anything you want to talk about."

Truth be known, I didn't believe you.

When you arrived in Chicago, you obtained the name of a high-end restaurant from the staff at the training center. You invited me to meet for dinner on Friday night and called to give me directions. I looked forward to seeing you as I drove to the restaurant. Though I considered it, I decided against giving you an ultimatum.

When I arrived, you were sitting at a table in the bar, typing on your laptop computer. In a flash of an instant a thought came to me.

He's going to ask me to marry him. No. That's absurd!

Dinner was wonderful and so was the company. As the wine relaxed us, the conversation flowed. Then you asked, "So what is it you want to talk about?"

Flushed from the wine, I flippantly replied, "Oh, it's no big deal, really. It's just that I've been wondering whether we are going to carry on with this long-distance relationship for the next ten years, or what? I respect that you don't want to discuss it, but I would like to talk about our future. More importantly, though, I cherish the time I spend with you, and I'm not willing to risk ending what we have between us."

Then . . . surprise, surprise! You slid an open black velvet box across the table toward me. It contained a dazzling solitaire diamond ring. In that same moment, you declared your love for me and asked for my hand in marriage. You told me that you had planned to propose for some time, but you wanted to be employed, to feel worthy of asking me. My instant of intuition had proven correct, but I was still stunned. I accepted your proposal without hesitation—my most self-indulgent decision ever. I was doing this for me, for my own happiness.

Later that night, I told you about my finances, giving you an opportunity to change your mind if you wanted to. Having struggled as a divorced mother raising four kids, I had used credit cards and had a second mortgage on my house. I had debt.

Your response floored me when you said, "That's my debt now."

I didn't expect you to say that. I knew that I would

eventually work my way out of that hole on my own. I wasn't looking for handouts. In the end, I did not come into the marriage completely empty-handed, but with a sizable balance from my company retirement account. I felt somewhat exonerated.

A few days after you proposed, you phoned me and said, "I just want you to know, divorce is not an option."

You didn't know that during my first marriage, my husband had threatened to divorce me several times, holding me in fear and under his controlling thumb. I had felt I was in the marriage alone and the only one committed to it. Sweet man, your words solidified my decision to marry you.

From that point, things quickly came together for us, as God had intended. My house went under contract within two weeks of our becoming engaged. Coincidentally, the buyer of my house told me that she had put dibs on my place more than two years earlier but had known that she would not qualify for a mortgage at that time. Obviously, I was not meant to sell the home earlier. God had another plan.

Then I found a job in Colorado. Commuting on the train into Chicago, I had asked an acquaintance if he knew any bankers in Colorado. The question was essentially hypothetical, as if I was thinking aloud. His answer was anything but hypothetical. He put me in touch with his sister, who happened to work at a community bank

in Lafayette, a small town east of Boulder. It was through a referral from her that I got hired at the Federal Reserve Bank of Kansas City (FRB), Denver Branch. After nearly five years as a bank examiner with the FRB, I went to work for that community bank in Lafayette. Ah, the twists and turns of life.

Once my house was under contract and I had found work in Denver, we set our wedding date. Invitations spread by word of mouth because we had only two weeks to plan the event. You had proposed on June 18, 1993. There we were, standing before the pastor of the church you had attended in Aurora, Illinois, exchanging vows on September 4th. The loaded U-Haul truck with my 1991 Honda Accord perched on an attached trailer awaited us in the church parking lot. After a brief reception at the church, we were on the road, heading west toward our new life together. I was overjoyed to become Mrs. Alan Gray, but the gravity of leaving my family was beginning to settle in on me. I shed silent tears as we drove into the night.

Neither of us knew the life challenges we would face. There were adjustments for both of us. No longer the nurturer of a terminally ill wife, you had your hands full with a spirited, confident woman. You struggled to get your footing with an active partner in your life again. You were unaccustomed to confrontation and my feisty personality sometimes frightened you. Early

on, you checked the closet to see if I had packed up and left you after a fight. You soon learned to trust me. I wasn't going to leave you just because we had disagreed. In retrospect, you referred to our first year of marriage as "the tumultuous one."

I tested your love for me, though, and I'm so sorry. I had been carrying around emotional baggage from my first marriage. Subconscious fears permeated my thoughts.

Can I relax with Alan and trust him with my vulnerabilities? Is he going to humiliate me? Mock me? Manipulate me?

You proved to be an extraordinary husband, friend and companion. You were respectful, trustworthy, sensitive, loving and true. I soon learned to let down my guard with you.

As you know, the move to Colorado, combined with traveling for the Federal Reserve Bank, took its toll on me. Please forgive me for being uncommunicative at times, especially when you called me on the road and I remained silent on the other end of the line. I was trapped in grief, yearning for my friends and family in Illinois, yet I wasn't fully aware of it at the time. You could have taken it personally, but you didn't. Instead, you were consistently patient and supportive, loving me unconditionally. Several times you drove three or four hours each way to unexpectedly spend the night

when I had an assignment at some remote western town. You were always a welcome sight.

Three years into the marriage, we found ourselves bickering—sometimes explosively—over insignificant matters. We sought out marital counseling. I appreciated that you were open and willing to face our problems and, ultimately, to enhance our life together. It takes two committed people to work through marital challenges. As with most troubled couples, we were not communicating our true feelings.

In our attempts to find a capable therapist, we met with three before finding Sharon. Sharon helped us clear up two veiled but important issues. First, she hit on a tender spot in me when she determined that I was still grieving what I had left behind when I moved to Colorado from Illinois. I had been harboring the pain. Who could I tell? I didn't want to complain to you because I didn't want you to feel responsible. I couldn't tell my coworkers because they might not be sympathetic. I couldn't tell my family or friends in Illinois because they were hurt that I had moved away. Once you fully understood this, you acknowledged my losses and subsequent suffering. It was exactly what I needed.

Next, you discovered that you were holding a certain expectation. You wanted appreciation for "saving" me from my former life. As soon as you spoke those words, in the next breath, you admitted that such an expectation was unreasonable. We were equal partners, both contributing financially to the marriage. In hindsight, I think that we saved each other—with our mutual love.

No matter what adversity we faced, our love for each other and our commitment to the marriage carried us. Though challenging at times, we were both determined to communicate, to stretch, and to grow. When we had a disagreement, we fought fair by staying focused on the issue at hand.

One weekend we attended a seminar on communication skills. There we acquired tools that helped us stop interrupting each other. It wasn't as if we were finishing each other's sentences. We interrupted one another to get our respective opinions on the table. The seminar leader stressed the importance of listening completely to the other's feelings and point of view before stating our own.

Late one Saturday night, we went to a twenty-four-hour truck stop to discuss a problem over pie and coffee. Neither of us interrupted the other verbally that night, but we cheated by writing down our thoughts on napkins while the other one spoke. Although the topic escapes me now, I remember we came to a better

understanding of each other and had a good laugh about our note taking when it was all over.

We both evolved, honing each other into broader-minded and better people. You found the good in others and you didn't sweat the small stuff. When I attempted to instigate a meaningless argument, you held me to a higher standard by saying, "That doesn't warrant a response." If I hurt your feelings, you told me. Humbled, it probably hurt me more.

You were cynical when we first met and I often challenged your seemingly narrow way of thinking. You were willing to expand your perspective and beliefs. For example, you stopped judging those who did not have a college degree, and you learned to appreciate all people for their personal contributions to society.

You also came to fully appreciate my children and grandchildren, respecting their individuality and calling them family. You stood united with me when my daughter, Sarah, became a single mom. Your support of her and your involvement in raising our grandson, Mitchel, left a lasting impression on their hearts and mine. With grace, you were hospitable when my son, Paul, and my daughter, Beth, needed a temporary home. When friends and family visited, you welcomed them. When Dad's health was failing, you offered him a place in our home.

I will never forget your sense of humor and the fun we had. Our friends, Dave and Carla, still talk about the night you stood by our table at La Familia, our favorite Mexican restaurant, and entertained us with goofy songs and stunts. We were all doubled over with laughter. You also had fun pulling practical jokes on Nathan, our waiter. Once you called the restaurant from your cell phone as we sat waiting to be served. You asked for Nathan and the bartender called out to him that he had a call from someone named Alan Gray. We watched as Nathan picked up the phone and said, "Hello." Then you asked him when he was going to get around to taking our order.

There was the gray-ponytailed baseball cap you wore to every bluegrass event I dragged you to and the "AL" belt buckle you wore when we occasionally went bowling with the family. You liked dressing the part, ensuring that you had all the proper gear for hiking, bicycling, country dancing, riding your Harley or whatever else you were doing. Privately, you reduced me to giggles when you modeled your cowboy hat and boots and, later, your leather motorcycle chaps—otherwise in the nude!

Openly affectionate, you freely accepted my love and loved me in return. Once, while lying in your arms, I

felt overcome with joy and said, "Thank you for letting me love you." Loving you was a privilege. Another time, I softly pounded your chest and declared that I needed you. For the first time, I understood the difference between needing someone because you love the person—the way I felt about you—and loving someone because you needed them.

You often made my day special when, for no apparent reason, you brought me a fresh bouquet of flowers, gave me a romantic card, or wrote a sweet message on a sticky note and left it on my desk. I also recall the time you sang into my voice mailbox at work, "I just called to say I love you." Whenever you walked into the lobby of the bank, my heart skipped a beat. Now I regret not always giving you my full attention as you sat across from me at my desk. Sometimes I was distracted with the day's business matters. Those matters seem so unimportant now.

You were romantic in many ways. Remember the time when we were an hour east of Denver, returning from our road trip to Chicago? Near midnight, you pulled off the road and we stood, leaning into each other against the car, gazing at the magnificent, star-filled sky. That sky was a reminder of just how insignificant we really are in the big scheme of things.

You were a Type B personality, bringing balance to my Type A. One Friday afternoon, as we headed toward Glenwood Springs for a weekend getaway, we stopped

in Frisco for lunch. Pulling into the parking lot of an Italian restaurant, we found it closed. You suggested that we grab a pizza and a couple of soft drinks nearby and find a picnic spot. Fixed on the idea of sitting down in a restaurant, I was resistant and inflexible at first, but eventually agreed. From Frisco, we drove a few miles west and exited at Officer's Gulch. There, in the warmth of the sun, we ate our lunch sitting atop a large boulder near the peaceful lake. Feeling relaxed, I expressed my contentment, saying, "Thank you for bringing me here!" You knew exactly what I needed: balance.

Not once denying the other, we enjoyed a healthy and fulfilling sex life. Sometimes we were recklessly opportunistic, stealing away for unusual encounters. One Saturday night we packed up our camping gear on the spur of the moment and found a secluded spot on Switzerland Trail, in the foothills behind Boulder. By the open fire, we lay naked on a blanket under the midnight sky, wrapped in each other. How I yearn to again feel your warmth against my body, the strength of your arms around me, and the soft scratchiness of your beard on my face.

You were also a good sport, consistently willing to pick up and go, whether it was to get to the theater for a movie starting in ten minutes or for a walk around the

neighborhood. You thought nothing of driving two hours each way to hike for an hour or to find a remote café for breakfast on a Sunday morning. Without complaint, you also endured my obligatory bank functions, standing by my side—my husband, my partner.

Your good sportsmanship impressed me, too, when you often ended up carrying my new, large backpack (something I insisted on having) along with your own as we hiked up a mountain. You took on more than your share of the load, too, when I convinced you to rent a tandem bicycle in Frisco. After struggling to get the timing and balance just right, we were off, heading toward Breckenridge. You ended up doing most of the work, pedaling uphill, literally carrying me along on the back.

You were my rock, my sanity. You patiently listened without judgment when I expressed my worries and frustrations about my job. When I fretted over the choices my kids had made and I questioned my abilities as a mother, you were there to reassure me with your insights and wisdom. Although I did not always deserve it, you were unwavering in your love for me throughout my menopausal years. I was unruly and irritable much of the time as the hormonal shift in my body caused raging hot flashes and restless sleep. How did you put up with me?

In the truest sense, you were my partner. Supportive, you encouraged me to follow my dreams. Although you had lost two jobs in one year when I was peaking in my career, you were sincere when you said, "I am happy for you, and I am so proud of you." You used to boast that you were the First Man, married to the [bank] President.

I was proud of you, too. Admirably, you drew upon your thirty years of business experience and started an office cleaning company. The entrepreneur in you forged ahead with confidence. Your new company, Corporate Cleaning Services, LLC, grew one contract at a time to nearly thirty in two years. You all but glowed, happy and free to be your own boss, taking pride in your accomplishments. I envied that freedom.

You were somewhat laid back and not overly concerned about the future. When Sarah asked what you would do if this or that happened, you always replied, "I'll deal with that when and if it happens."

In an effort to thwart turnover, you hired good people and paid them better-than-market wages. You valued your employees and held them to a high standard, striving to provide excellent customer service. You were generous at Christmas, ensuring that each employee received a prorated bonus and an all-expenses-paid Christmas party. Consequently, you were unable to pay yourself the month of January 2002. That was a

small consolation for the pleasure it gave you to honor your employees, wasn't it? I remember being testy with you for not planning ahead, but figured what was done was done. Today, I would think, *So what?*

Systematically, over two years, you acquired the majority of the cleaning contracts with the twelve branches in my bank's group, among others. Then it seemed as if your world was caving in when you learned that management at the corporate level had agreed to put the branch contracts out for bid in early 2002. With grit and finesse, you faced the reality that you might lose the contracts to a lower bid. If that happened, you would be forced to lay off some of your people, a difficult thing for you to consider.

Agonizing with you, I felt helpless. Sure, I was regional president over three branches, but there were "the powers that be" in administration. Personally, I was embarrassed by their lack of professionalism. The action seemed to be stemming from some obscure, internal political movement. It appeared as though one or more of my peers who wanted to see you fail had influenced upper management. You left this world before you received the dismissal letter. I guess you had the final say in it after all, didn't you?

People tend to idealize loved ones who have passed away and, perhaps, I am guilty of that from time to time. Admittedly, our marriage wasn't perfect. It consisted of two imperfect beings. Taking all things into consideration, however, our marriage was perfect in its imperfection. It was a healthy relationship. We checked in with each other by phone every day. And the daily affection in the form of good-bye and welcome-home kisses, along with the intimacy we shared, kept us close. Neither of us enjoyed burning daylight when unhappy with the other, so disputes were resolved quickly. Alan, the day you passed, I loved you, and I believe you loved me, more than the day we married.

From my point of view, you left way too soon. I had optimistically expected we would live well into our eighties, sharing all that life has to offer and growing deeper in our love for each other. Throughout my entire life up to meeting you, I believed that the love portrayed in books and in movies was make-believe. With you, I experienced it all in the form of unconditional love. You set the bar high.

It is my desire to carry on your legacy in my relationships with others. You were free spirited but responsible. You valued life, embracing each day to the fullest and living in the moment, neither bitter about the past nor worried about the future. We had a good life together.

Throughout eternity, I will remember your love and always love you, Alan Gray.

Your Wife,
Doris

P.S. I have some questions that may never be answered now that you are gone, but I cannot help but wonder about them. *Was I a good wife? Did you know the depth of my love? Did I say, "I love you," enough? Did I tell you how much I appreciated you enough? Was I enough?*

Part III:
Signs of Alan

There are only two positions you can take.
Either you believe that nothing in life is a miracle,
or you believe that everything in life is a miracle.
~ Albert Einstein

CHAPTER 1

My Day, the Day of the Accident

It was sometime between 10:30 and 11:00 p.m., more than eight hours after the accident, when I learned about it.

The day had started out as usual. After showering and progressing through my morning routine, I prepared to leave the house at 7:30 a.m.

Alan lay awake on the bed, troubled about the possibility of losing his biggest client, the bank where I was employed. Thinking out loud, he questioned whether the branch managers had been less than frank with him about the level of service being provided by his company. He had regularly stopped at the branches, attempting to maintain an open dialogue with management about the quality of service. Except for the persistent issue of maintaining the granite flooring at one particular branch, to the best of his knowledge, the few other complaints had been resolved. Alan asked if it was possible his employees were not providing satisfactory service.

"I guess that's something you have to consider," I replied and bent over to kiss him.

Later that morning, I called Alan from the bank to see how he was feeling. I encouraged him to hang in there and reminded him that all things work together for good. We could choose to look at the glass as half empty or half full. There were several other clients. New business was being referred on a regular basis. His company would recover if he lost the branch contracts. He would rebuild it, one contract at a time. Then I suggested he take a ride on his Harley and forget about the stressful situation. It was out of his hands and mine. Besides, it was a gorgeous spring day! Our last words as we ended our phone conversation that fateful day were, "I love you."

Mid-afternoon, perhaps around the time Alan took his last breath, I dialed his cell phone and got his voice mailbox. Unsuspecting, I left a quick message and attacked the files stacked on my desk. At 5:30 p.m., all of the employees had left the branch except for one teller, Ryan, and me.

Relaxing a bit, I opened up to Ryan, saying, "You probably find it hard to believe, but I was in the 'hood' when I was in junior high school. Now, I'm this conservative banker and Alan is my alter ego. He rides a Harley. He wears leathers. He got himself two tattoos and pierced his left ear—all since he turned fifty."

Ryan smiled and asked whether I ever rode with Alan and whether we wore helmets.

Lighthearted, I replied, "No, our philosophy is that if you're going to go down, do you really want to live?"

Then we said good night as he left the building and I locked the door after him.

As I cleared my desk, I dialed Alan's cell phone. No answer.

He must be vacuuming, or he left his phone in the truck.

I didn't want to go home. Sarah and Mitchel had been gone every night that week. Sarah had been house-sitting for a friend and had left that day with another friend to spend a few days in Silverthorne. Alan had taken on three new cleaning contracts, so he was work-ing those jobs every night until he could hire his next employee.

As much as I disliked shopping, I stopped at the mall in Boulder. I was bored after forty-five minutes. I had noticed the marquis at the local theater while driving from my office to the mall, announcing the showing of the movie *Iris*. That movie had been nominated for Academy Awards in three categories and had won one.

That's what I'll do. I'll see that movie. Alan probably wouldn't want to see it, anyway.

Before entering the theater, I tried to reach Alan again. No answer.

Maybe something is wrong. Should I go home? No, I'll

get there and everything will be fine. I don't want to be home alone, again, tonight.

Taking in a movie solo was a new and different experience for me. As I walked through the lobby, hands filled with popcorn and a soft drink, it seemed surreal, as though I were in a dream.

Floating. I'm floating.

Immediately after the movie ended, I made a beeline to my car and grabbed my cell phone. Normally, the screen would have read "4 missed calls."

No missed calls. That's odd.

I drove an alternate route home, one that would take me through Lafayette. Alan usually worked a job there on Thursday nights, but his truck was not there and the building was dark.

He must have changed his routine tonight.

After filling up my gas tank in Lafayette, I drove toward home. On the way, I repeatedly dialed Alan's cell phone, our home phone, and his office phone. I also checked for voice mail messages at work and at home. Nothing.

When I got within five miles of home, I started to panic and to bargain with God.

Something must be wrong. Dear God, please keep Alan safe. I'll be a better wife.

Turning into our driveway about 10:15 p.m., I pressed the garage door opener and entered the garage. Alan's truck was parked in the middle bay. Frantic, I jumped

out of the car and ran around the truck to the outer bay where his bike was usually parked.

No Harley!

Shouting his name over and over, I darted from the garage into the house, checking every room and turning on every light. I ran into the backyard, then back into the garage.

Is this my imagination? No, the truck is there and the Harley is gone! Alan would not be riding the Harley this late. He would be working!

Not knowing where to turn or what to do, I automatically dialed my son, Paul. Upon hearing his voice, I urgently expressed my concern for Alan.

"There may have been an accident. He could be in a hospital somewhere! Please, will you come? I need you here!"

Paul patiently replied, "Mom, calm down."

Frustrated, I threw the receiver down on the kitchen counter.

Don't tell me to calm down!

Alan enjoyed riding with his friend, Sid.

Sid may know where Alan is. Alan may have stopped to see him today!

I dialed Sid's number. His wife, Connie, answered my call, and she asked Sid if he had seen Alan. No, he hadn't. Connie said they were getting ready for bed, but they would wait to hear from me.

My daughter, Beth, called from her friend Rachel's car. Rachel had been staying with Paul and Beth for a couple of weeks. "We're on our way, Paul, Rachel and I."

Now what? Dial 911, the Westminster police.

Overwrought, I explained the situation to the young man who answered, articulating my concern for Alan's safety. "Something is wrong, very wrong. Do you have a record of an accident? I'm afraid he may be hurt and in a hospital as we speak!"

The young man calmly stated that, no, he had no record of anything related to an Alan Gray. Then he offered to hold a conference call with someone from the Adams County Sheriff's Department.

That someone came on the line. "Does he live at 11318 Quivas Way?"

"Yes! What happened? Where is he?"

"Your husband was pulled over around 7:00 p.m. tonight, but I have no details. The officer who pulled him over is off duty now."

Breathless, I exclaimed, "What? Can't you call the officer at home? I need to know!"

The two young men assured me that they would look into it and call me back. In what seemed like mere seconds after ending that call, I heard the garage door rising.

There he is! He's home!

Rushing into the garage, I saw four police officers

and [what I was to learn shortly] a victim's advocate approaching from the left side of the driveway. Having arrived at the same time, Beth, Paul and Rachel were standing on the driveway to my right. They had used the keypad to open the garage door.

With outstretched arms and hands held up as if to block the dreadful news, I murmured, "No, don't tell me. Don't tell me. I don't want to know."

Softly, Beth said, "Mom, we already know."

Imploringly, I looked toward the officers. They confirmed it by the looks on their faces. Alan was gone.

Pain sliced through me like a machete, first splitting my heart in two, then cutting me off at the knees. Paul reached for me as I collapsed in his arms, sobbing.

This cannot be true! There's been a horrible mistake!

Next thing I knew, I was sitting at the kitchen table with Paul and Beth. My world had caved in and I was in a state of oblivion. Rachel (someone I did not know well but who would eventually become a member of the family) was at the table, too, but I failed to even notice her. Paul sat close to me with his arms draped around me, holding my hand.

Devastated, I proclaimed, "I can't live without Alan. There's no way. He was so good to me. I need him. I can't live without him!"

Through his tears, Paul said, "Mom, you are the strongest woman I know."

"No, no I'm not. Not really. I don't want to have to be strong."

Alan let me be soft and feminine. He took care of me.

The officers and the victim's advocate stood on the other side of the kitchen island and described the details of the accident. They said there were several witnesses. One stated that Alan had narrowly missed being hit by another vehicle just moments before the accident. That witness remembered seeing Alan swerve out of the way to avoid a collision. In the next moment, Alan didn't stand a chance when he got hit from behind, unaware.

Was God tracking him down saying, "This is your appointed day, Alan"?

Agony coursed through my veins and left me feeling raw and agitated. I was inconsolable. The victim's advocate was trying to do what she was trained to do, but I wouldn't have any of it. She reminded me to breathe. She offered me a drink of water. She tried to comfort me with words, but every word that came out of her mouth felt invasive.

Who are you? You don't know me. There's nothing you can do to help me!

The police had come to the house to report the accident at 5:30 p.m. and at 8:00 p.m. No one was home at

either time. Typically, Sarah and Mitchel would have been home at 5:30 p.m. Had I not gone to the movie, I would have arrived home around 7:00 p.m. and would have been alone at 8:00 p.m. As the circumstances had unfolded, Paul and Beth were, thankfully, there for me at the critical moment—the moment I received the horrifying news. Normally, it would have taken them thirty-five to forty minutes to get from their apartment in southeast Denver to my house. It seemed as though it took them half that amount of time.

They came on the wings of an angel.

My route home from Boulder that night had kept me from driving through the intersection where Alan had died. Coincidentally—or through a subconscious premonition—three months earlier, I had started passing through that intersection at Zuni Street and turning elsewhere into our subdivision.

Why am I taking this route? Is my car on automatic pilot?

I would never turn at Zuni Street again.

Before leaving for the mountains, Sarah had called me with the telephone number where she could be reached in Silverthorne. Busy at work, I had attempted to brush her off, but she insisted I write down the number. Without it, I would not have known how to reach her.

Beth made a few calls to immediate family members

and friends that night. Connie and Sid came over. Alan's brother, Rob, and his wife, Kaaren, were staying at their vacation home in Silverthorne. After inflicting the news on Rob, Beth gave him the phone number to reach Sarah and asked him to bring Sarah and Mitchel home. "Yes, tonight. Mom needs them here."

Rob and Kaaren arrived at the house with Sarah and Mitchel around 1:30 a.m. Mitchel had slept through the drive and he was transported, fast asleep, to his bed.

No need to wake him tonight. We'll tell him in the morning that his Papa is gone. Gone!

Meanwhile, Beth called a friend in Oswego, Illinois, and asked him to go to my other daughter's home and awaken her. Jamee was not answering the telephone. Crushed with the weight of the news, Jamee called us immediately. She offered to notify Grandpa, my dad. Jamee, my grandson Devin and Grandpa would be on the earliest flight from Chicago to Denver in the morning.

While it seemed that the world stood still, time passed us by that night. We sat powerless and crippled, immersed in the trauma and the pain, until dawn. We were robotic in our movements. Confused. Raw. People came. People went.

Alan will walk in the door any minute now. I'm sure of it.

58

CHAPTER 2

A Family for Alan

Alan's parting words to me had been, "I love you."

My ex-husband's parting words had been, "Nobody will ever want you with four kids."

That's okay. I had five (including you). Now I have four. Who needs a man, anyway? And, remember, you have four kids, too.

It would be six years after my divorce before I started dating. I needed time to rediscover myself. I didn't want to repeat history by attracting the wrong man into my life. Besides, my kids were my priority. My survival instincts were activated, creating a hunger for success in my career.

During our initial telephone conversation, I told Alan about my four children, ranging in ages between fifteen and twenty. Undaunted, he asked to meet me for coffee the following evening.

Alan regretted that he and Nancy had not had children. Throughout their first eight years together, Nancy had focused on other goals, specifically, teaching and

59

then working toward her doctorate. Children could wait. Once she was diagnosed with the brain tumor, the doctors recommended that she avoid pregnancy. Without hesitation, Alan had chosen to have a vasectomy. Nancy's life was far more important than a risky pregnancy.

While dating and during the first couple of years we were married, Alan was easily annoyed when a child fussed or acted silly in public. Conversely, I enjoyed the distraction, having always delighted in the pure wisdom and charm of young children.

He doesn't remember what it's like to be a child. Neither has he experienced the joy of raising one.

Three months after we married, Sarah moved to Colorado. She was eighteen. She had attempted to make it on her own in Texas but had returned to Illinois. Alan sensed my angst about her floundering life path and suggested we fly her to Colorado on a one-way ticket. She stayed with us for four weeks, then found employment and moved in with a coworker. Colorado would be her home for more than nine years.

Alan struggled with relating to my kids. Having Sarah nearby and involved in our life together was an adjustment for him. He viewed it almost as an intrusion. He had believed our life would consist of only the two of us, husband and wife. Alan was ill-equipped for kids of any age. At times, I had to address his lack of

sensitivity, his almost demeaning attitude when talking to Sarah. Later, when Paul came to live with us while attending a local community college, we had similar conversations.

Once, Alan mentioned that he might want to visit Belize.

Sarah shrugged her shoulders and said, "I don't know where that is."

Incredulous, Alan proclaimed, "You don't know where Belize is?" Then he stood up and left the room to find his world atlas. In a condescending tone, he pointed to the atlas and said, "Here it is, right here in Central America."

Sarah quietly responded, "Oh."

Having witnessed the interchange, I confronted Alan when we were alone. "Alan, you cannot talk to my kids like that. Big deal, you know your geography. You struggle with spelling. How would you feel if someone belittled you like you did Sarah?"

Frustrated, he declared, "I don't know how to talk to them!"

"Granted, you did not raise children of your own, but surely you can remember being one of six while you were growing up. Try to put yourself in their shoes."

Over time, he learned to relax and enjoyed conversing with my kids.

Thank you, God.

Another time, Alan told me he was uncomfortable with Paul, saying Paul's intelligence intimidated him. Surprised by his insecurity, I assured him that he underestimated his own intelligence. He also had a great deal of wisdom and life experience. I suggested that he and Paul might learn from each other.

One evening, after we had been married six months, we were having a glass of wine on the deck. Alan expressed his feelings about my kids. "I'm envious that you have children and I have none. And I'm jealous that you are so close to your children."

Empathetic, I explained that children are truly a blessing and admitted that I was extraordinarily close to mine. Then I added, "This is not a competition. I love each of you deeply. Don't make me choose. You are my life partner, fulfilling a completely different need in me than my children. Besides, I want to share my family with you."

October 17, 1994, our first grandchild, Devin, was born to Jamee. On an emotional roller coaster ride, I was sad about missing his birth, yet thrilled with my new role as grandmother. It was difficult to be 1,000 miles away with job constraints. Alan and I were planning to spend the Thanksgiving holiday in Illinois, so Devin would

be five weeks old before we would meet him for the first time. Filled with love and compassion, Alan called me at work that day and suggested I fly to Chicago for the weekend.

You wonderful man!

That evening, when I returned home from work, I found a greeting card taped to the garage door leading into the house. It was a congratulatory card on becoming a grandmother. On the inside of the card, Alan had written, "You may be a grandma now, but you sure don't look like one. I love you."

Devin was five days old the first time I saw him and held him in my arms. Jamee was surprised to see me and thankful that I had come. Five weeks later, Alan and I drove to Chicago, as planned, and I was able to spend more time with that special baby boy. Returning to Colorado was hard. I would only get to see my grandson two or three times a year.

I will be missing out on so much.

Then along came Mitchel.

Mid-December 1995, I had made plans to do some Christmas shopping with Sarah. I picked her up from her nanny job in Denver and she settled into the front passenger seat, appearing extremely fatigued and distressed. In response to my questioning look, Sarah tearfully confided that she was pregnant. She was twenty and single, living in Denver, using public

transportation, and working as a nanny with no medical benefits. Upon hearing the news, the biological father had decided that he wanted nothing to do with her or the child. She was overcome with humiliation and desperation.

Having lost interest in shopping and needing to talk, we drove to a local restaurant for coffee. I knew full well that Sarah needed to make the right decision for herself and said, "No matter what you choose, I will be there to hold your hand."

Sarah immediately ruled out abortion, believing that she could not live with that choice.

Thank God.

Alan could see that I was upset and asked me what was wrong when I returned home that night. I shrugged it off. I was feeling overburdened and could not find the words to tell him.

What will Alan think? This is not something he bargained for when he married me.

I left a note for Alan the next morning. "Sarah is pregnant and I can't talk about it right now."

Two days later, while driving home from the grocery store, I wondered what my mother would have done in this situation. I recalled that twice, when already married and in my mid-twenties, I had overheard my mother tell her friends, "If either of my daughters had gotten pregnant in their teens, I would have raised that child."

Then the floodgates opened and tears streamed down my face.

After pondering the situation for a couple of days, Alan was open to the discussion that needed to take place between us. He confessed that before he had married me and started listening to Dr. Laura, he would have reacted selfishly to the situation. "Dr. Laura would say, 'Do the right thing.'" Alan and I agreed that Sarah could move in with us, but she had to have a plan to gain financial independence. With great love in my heart for him, I told Alan that this small child would touch his life as nothing else ever had—assuming Sarah chose to keep it.

Without my knowledge, a few days later, Alan left a card and a Precious Moments figurine of a pregnant woman in the guest room where Sarah was staying. The card offered support for her condition, with a handwritten note, "I will be here for you." Not once did Alan discount her or judge her in any way.

A few weeks later, Sarah found the courage to call and break the news to her father in Illinois. In so many words, he had insisted that she should get an abortion, that there was no way she could raise a child on her own.

Thank you, God, for Alan. Thank you, thank you, thank you.

In a state of depression and angst, and physically ill

from the pregnancy, Sarah lay quietly under the covers in the guest room for hours on end. I respected her right to choose and had kept my opinion to myself. Adoption was still an open option for her and the baby.

Finally, I couldn't keep quiet any longer. Standing in the doorway to the guest room, I said, "Sarah, I already love this child."

Relieved, she replied, "If I can find a way to raise it on my own, that is what I want to do."

The pregnancy was difficult. Sarah could keep nothing in her stomach during the first four months. As a result, she was unable to maintain her job and, subsequently, her apartment. She moved in with us. The initial plan was for her to enroll in general education classes in the fall and work toward a bachelor's degree in elementary education. Her goal later changed to attaining certification as an American Sign Language interpreter.

Sarah found guidance and support for single moms through Real Choices Pregnancy Care Center in Boulder. Alan and I participated in her birthing classes at the center. We shared in the joy on August 12, 1996, along with Paul and one of Sarah's girlfriends, when Mitchel came into this world.

Soon thereafter, Alan was dubbed "Papa."

Laying the ground rules, I reminded Sarah that Alan and I had a life, too. If she made plans with friends and

needed someone to watch Mitchel, she should not assume we would always be available. She would have to ask us. And she did.

Naturally, we became Mitchel's built-in babysitters. We didn't mind. Whenever we were unoccupied, we willingly kept him and cherished every moment.

My love for Alan deepened as he expanded himself, growing to care for my kids and my grandchildren.

Love me, love my family.

Ultimately, our collective love for Mitchel bonded us as a family.

Since Mitchel's biological father lived in the Chicago area and was not involved in his life, Alan took his role as Papa seriously. On a regular basis, he bantered with me and Sarah about being too soft and overly attentive with Mitchel. When Mitchel needed discipline, Alan's gentle but booming voice was sufficient.

Alan modeled the way by involving Mitchel in daily chores, projects, and activities. He took regular walks with Mitchel hoisted on his shoulders and, later, toddling behind him. Alan also had fun with Mitchel, running through the sprinklers, giving him rides in the wheelbarrow, visiting the local playground and making pizza.

Mitchel was fascinated with his Papa. At twelve months old, he would hold Alan's face between his little hands and stare adoringly into his eyes. Sarah and I often declared in dismay, "What are we, chopped liver?"

As he added skills, Mitchel started to express his love and affection verbally. Often, as Alan sat watching television, Mitchel would crawl into his lap and say, "I love you, Papa."

Giving him a squeeze, Alan would automatically counter, "I love you, too, Mitchel."

Alan showed his love to both of his grandsons in many ways. When Devin visited each summer, Alan tracked both his and Mitchel's heights on a pole in our basement. He also planned outdoor activities with the boys, such as flying kites, playing t-ball, camping in the backyard, and hiking on mountain trails. Watching television was not an option.

One time, Alan set up the tent in the backyard for the boys. They roasted hotdogs and marshmallows over the fire Alan had built in our fire pit and chased each other around the yard. At 10:00 p.m., Alan gave each boy a flashlight and told them they could stay up as late as they wanted to, as long as they remained in the tent. The boys—six and four years old at the time—were excited at the prospect but fell asleep within ten minutes. Amused, Alan continued watching the dancing flames die to embers before retiring into the house.

Alan's life had changed dramatically, thanks to the children and grandchildren. On our eighth wedding

anniversary, he gave me a lovely greeting card. The words in this particular card remain in my heart: "I can't remember my life before I met you."

Alan and I celebrated my birthday at a Denver restaurant in January 2002. At dinner, comfortable and content, Alan reached across the table and took my hands in his. "Thank you for bringing so much dimension into my life. I love you."

Years earlier, when we chose to help Sarah by providing room and board, Alan had asked me how long it would be before she was out on her own again. I told him that, realistically, it would be at least four years. Sarah looked forward to being on her own and planned to move out once she completed her studies and found work.

A few weeks before the accident Alan said to me, "Maybe they should live with us until Mitchel is eighteen."

How you've changed.

In the middle of the night following the accident, Rob and Kaaren stood in the kitchen, listening to us as we explained the circumstances surrounding Alan's departure. In my wretched state of mind, disconsolate and anguished, I declared, "Alan was so good to me! He gave me so much! What did I give him?"

Tearfully, Kaaren blurted out, "Doris, you gave him a family!"

Oh. Right. That must be Alan speaking through Kaaren, reminding me that I did give him something— a family.

CHAPTER 3

Who Knew?

As I look back, I see how certain circumstances and coincidences that occurred before the accident might have been premonitions. Was God preparing us for what was to come?

One Sunday afternoon in May 1992, Alan was packing boxes in preparation for his move from Illinois to Colorado. I stopped by his house to say hello. During our conversation, I mentioned that Paul would be turning sixteen soon and would be getting his driver's license. As if thinking out loud, Alan faintly stated, "Another killer on the road." I found his comment disconcerting but did not challenge him.

This isn't about Paul. Alan barely knows Paul.

Now I find it curious that Alan met his death ten years later at the hands of a sixteen-year-old driver.

Within hours of learning about the accident, Sarah and I shared how we each had sensed impending doom. Sarah said she had believed *she* was going to die.

In fact, the day before Alan's accident, she had felt compelled to visit the cemetery where a friend's infant child had been laid to rest. There, at the graveside, Sarah had explained death and the afterlife to Mitchel. At the time, she thought she might be preparing him for *her* death. She went so far as to destroy things in her room that she would not have wanted anyone to see.

I felt it, too.

I'm going to die.

Generally healthy, I had suffered from acute heartburn and gout around the Christmas and New Year's holidays preceding Alan's passing. A couple of years after the accident, I read the book, *You Can Heal Your Life* by Louise Hay. She makes a connection between heartburn and fear, clutching fear, and between gout and control or lack thereof. Did my subconscious and my body sense what was to come?

In previous years, we had burned a decorated Yule log on Christmas Day. According to legend, burning the log would bring good will throughout the New Year. Days before the accident, the log still sat on the deck lounge chair.

That's odd. Here it is March and we have not burned the log.

Later, I discovered our friends, to whom we had gifted Yule logs that year, had not burned theirs either.

On every New Year's Eve, Alan and I sat together and listed our goals for the New Year. The New Year's Eve

prior to the accident, we had spent a quiet evening at home with Mitchel. The gout was giving me a great deal of discomfort that evening, so I drove myself to the hospital emergency room around 10:30 p.m. and remained there through the midnight hour. Alan stayed with Mitchel and had gone to bed long before I returned home.

No list this year.

Alan also might have felt impending death. A few weeks before the accident, as we were driving home after a movie, he said, "If anything happens to me, I know you will be all right."

What?

Early on the day before the accident, I asked Alan if he had spoken to Rob about our plans to visit him and his family in the mountains over Easter weekend, just three days away. No, he hadn't. Later, Rob told me that Alan had called him that same afternoon but had not mentioned any weekend plans.

Did Alan know he wasn't going to be here for Easter weekend?

While we were on the phone that day, I also suggested we spend our April getaway weekend at Gold Lake Mountain Resort. In a distant voice, he asked, "Is that what you want to do?" Ordinarily, he would have responded with enthusiasm, volunteering to make the reservations. Alan wasn't making plans.

73

One night, a few weeks before his death, I tried to reach Alan on his cell phone around 8:00 p.m. He did not pick up and I did not leave a message. As usual, I went to bed at 10:00 p.m., but I was restless and unable to sleep. By the time Alan got home at midnight, which was normal for him, I had worked myself into a furor. Unfortunately, I took it out on him.

When he came into the bedroom, I delivered a verbal onslaught, saying, "Why haven't you called? I've been worried about you! I'd be better off single. That way, I wouldn't have to worry about anyone." It was an odd thing for me to say because I loved being married and had absolutely no desire to be single again.

Alan slipped out of the room and did not come to our bed that night. I assumed he was on the sofa in the family room, but when I came looking for him in the morning, he was neither there nor on the living room sofa. My heart sank as I opened the door to the garage, thinking he might have actually left the house. No, his truck was there. Then I noticed that the door leading to the basement was ajar and walked downstairs. There he was, rolled up in a sleeping bag, lying on a mattress on the floor with our dog, Sadie. My stomach churned with guilt, remorse and shame.

Disgusted with myself, I apologized for my behavior.

Alan said, "I left my cell in the truck while I was working in Lafayette. When I got to the truck and noticed

you had called, it was after 10:30 p.m. There was no message, so I figured it wasn't important and decided not to call and wake you."

Oh. I am such a bitch.

If I could take back those words, I would.

The day of the accident, Sarah, Mitchel and Sarah's friend, Elaine, drove to Silverthorne, Colorado. They planned to stay for a few nights. On the way, and completely out of context, Mitchel said, "Papa's going to die." Sarah immediately reassured him.

The following day, Sarah called Elaine and asked if she remembered Mitchel making that statement. Elaine said, "Yes. He said it twice, once at lunch and again in the car."

Did Mitchel really know?

Who knew?

God. That's who.

CHAPTER 4

Calls from Heaven

It was the night before Easter Sunday, two days after the accident. Dad, Jamee and Devin had arrived from Chicago. Mark, Sarah's boyfriend, was also staying with us. By 11:30 p.m., Sarah, Mark and I were the only ones who had not yet settled in for the night.

None of us had given a thought to Easter because we were frozen in time, still in a state of shock. Among many thoughtful gestures those initial days after the accident, Connie and Sid had brought over two dozen hard-boiled eggs that morning. Devin and Mitchel had colored and decorated the eggs, and it was Mark's job to hide them for the morning's hunt.

Mark wanted to place the eggs throughout the house, but Sarah insisted that he hide them in the backyard. Mark went off to hide the eggs, leaving Sarah and me standing across from each other in the kitchen, on either side of the island counter. As we stood talking in hushed voices, I heard the phone ring in Alan's office,

which was on the lower level of the house.

Must be a wrong number.

Within ten seconds after that phone stopped ring-ing, Alan's cell phone, which was sitting on top of the refrigerator, started to ring. Sarah grabbed it and said, "Hello? Hello?" Silence. The number identification screen displayed the words, "unknown caller."

Within the next ten seconds, the phone on the kitchen wall began to ring. Sarah reached for the handset and said, "Hello?" Silence again. Peaceful silence.

Sarah dialed *69, and the recorded voice said, "Number blocked." We also checked the caller identifi-cation on Alan's office phone, and it read "unknown." At once, Sarah declared, "Mom, there is no phone number in heaven! It had to be Alan calling to say good-bye!"

Is this a real possibility?

Sarah and I used all three of those phone numbers. And those were the same three numbers that I had re-peatedly dialed while driving home the night of the accident. Other family members, friends and Alan's customers might have known as many as two.

Must have been Alan.

CHAPTER 5

The Angel

The mortuary gave us a couple of options for the cover of the funeral program and contents. For the cover, we chose an eagle in flight with the American flag muted in the background. Alan's Harley had a custom eagle airbrushed on the front and sides, and he had searched high and low for a flag after the 9/11 terrorist attacks, six months prior to his death.

The program cover will represent the spirit of Alan Gray.

Then we chose the following poem to be printed on the inside cover:

I'm Free

Don't grieve for me, for now I'm free.
I'm following the path God laid for me.
I took His hand when I heard Him call.
I turned my back and left it all.

I could not stay another day, to laugh, to love,
to work or play.
Tasks left undone must stay that way.
I found the peace at the end of day.

If my parting has left a void,
Then fill it with remembered joy.
A friendship shared, a laugh, a kiss.
Ah, yes, these things I, too, will miss.

Be not burdened with times of sorrow.
I wish you the sunshine of tomorrow.
My life's been full.
I've savored much, good friends, good times,
a loved one's touch.

Perhaps my time seemed all too brief,
Don't lengthen it now with undue grief.
Lift up your hearts and peace to thee,
God wanted me now; He set me free.
~ Anonymous

As I read the words, they resonated in my heart. Alan consistently had demonstrated an optimistic attitude in life. He would in death, too. It wasn't that he wanted to die, but Alan was ready when God called his name. And without a doubt, he would expect all of us who loved him to get on with our lives.

A couple of days before the funeral, I couldn't sleep and got out of bed at 4:00 a.m. While the others slept, I quietly made my way down to Alan's office. Sitting there in his big, comfortable desk chair, I somehow felt closer to him. After sorting through a few papers, I typed the poem, *I'm Free*, in a large font on 8 ½ by 11 paper.

I'll tape it to the refrigerator to remind me of Alan's optimism.

When I went to save it to a Microsoft Word folder, the first words of the document, "I'm Free," normally would have appeared in the file name bar. Instead, there was a dark orange, angel-like figure at the left end of that bar and no words.

What is that?

I went back into the document and tried to save it again. The same angel-like figure appeared in the same place. Shrugging it off, I proceeded to type over it, naming the file "I'm Free." Finally hitting the point of exhaustion, I climbed the stairs to my bedroom and found sleep there.

Was that you, Alan? Are you my guardian angel now?

The following morning, Beth came over to the house and showed me a poem she had written the previous night—the same night I had my "angel" experience.

Harley's Angel

I'll bet that was the ride of his life.

To free your mind, you can count on the bike.
The wind blows away the things that are wrong,
And the sun brings the love that has been all along.
The mountains in the distance call your name,
The road is welcoming and it wants you to stay.
The sky opens its arms without rejection,
You fly with the birds and they have no objection.

I bet that was the ride of his life!

To free your mind you can count on the bike.
~ Beth Adkins

Beth had ridden with Alan a few times and understood the joy of the ride. She had nailed it. If Alan had to go, what better way to go out of this world than riding his Harley on the road to heaven, the most glorious of all destinations? She granted permission to print it on the back of the funeral program (and in this book).
Alan would like that.

CHAPTER 6

The Limo Ride

The funeral was to be held on April 4, 2002, exactly one week after the accident. Arrangements had been made to have a limousine service drive the immediate family from our home in Westminster to the mortuary in Boulder, then to the cemetery and back home.

Alan's riding buddies, Tom and Sid, offered to lead the procession on their Harleys. They planned to wear their full riding gear, leathers and all.

Alan will love this.

Settling into the limo, the driver offered my father the front passenger seat. I sat directly behind Dad on the bench seat and Paul sat to my left, in the middle position. Jamee, Beth, Sarah, Devin and Mitchel were in the limo, as well.

As the procession was readying to leave, the limo driver offered to crack the passenger window for Dad. He opened it approximately half an inch to provide a

little fresh air. The limo windows, of course, were darkly shaded.

All at once, astonished, Paul asked, "What is that? Where is that coming from?"

There, on the back of the seat Dad occupied, were a multitude of small rainbows, floating before me against the darkness of the leather. Paul pointed out the source. The thin ray of sunlight passing through the front passenger window was striking my diamond ring. The diamond, acting as a prism, created the spectra of colors, an extraordinarily beautiful display. Peace enveloped me.

It's a sign from Alan, a sign that all is well and that he's still here.

It was about a thirty-minute drive from the house to the mortuary. As the limo passed through the outskirts of Boulder, without forethought, I began to sing "Down to the River to Pray." The family joined in.

Where did that come from?

After the graveside service, we climbed back into the limo and headed home. As we were departing Boulder, without conscious intention, I murmured the lyrics to the song, "You Are My Sunshine." And, again, the family joined in.

Alan, you are my sunshine.

Once home, the driver stood outside the limo to say good-bye. "I have never been so blessed," he said.

"Driving you and your family has been an extraordinary experience for me today. Thank you."

Even the limo driver senses something remarkable is happening.

CHAPTER 7

The Funeral: So Much Love

"I've never seen so much love."

That is what Alan had said when my mother died in April 1992.

My mother had lived an active life, one filled with a joyful spirit and an optimistic attitude. She died unexpectedly of heart failure at the age of eighty. Her funeral service was simple. My friends Jill, Dan and Chris, played their acoustic instruments and sang inspirational bluegrass music—her favorite. In addition, Beth wrote a lovely tribute to her grandma, expressing gratitude for all the time and the love her grandmother had given her. The pastor read it at the service.

Alan's comment that he had never seen so much love as the love at my mother's funeral had made me wonder.

Really? What did he see?

Alan's funeral service was filled with much love, as much or more than he had witnessed at my mother's

service ten years earlier. The outpouring of sympathy in the form of cards and flowers and the support of family and friends was staggering. As the family entered the chapel on the night of the visitation, the attendant proclaimed, "Be prepared. There are many, many flowers."

About as many as have been delivered to the house.

Jill and Dan played bluegrass music at Alan's funeral, as they had at my mother's. Neither had visited during the years I had lived in Colorado. I felt deeply blessed that they came for the funeral, toting their instruments: a guitar and a mandolin.

I had chosen two songs for the service, "Down to the River to Pray" and "On the Banks of the River Jordan." I had planned to take my bluegrass CDs to the mortuary. I didn't need them. Dan and Jill said they knew both songs and could perform them at the service. They offered to play a third song, "Until Then," at graveside.

Later, after the funeral, the sounds of bluegrass drifted into the cobalt blue, mid-afternoon sky as Jill and Dan played their instruments and sang in my backyard for friends and family.

Soothing sounds. Comforting words. Jill and Dan were sent to nurture us with their music.

Each of my kids readily agreed to say a few words in honor of Alan at the service. The night before, five-

year-old Mitchel had told Sarah he wanted to speak at Papa's funeral, too. Sarah and I joined him in the family room as he shared what he had prepared on small pieces of note paper.

Our faces were wet with tears as Mitchel stood before us, dry-eyed and serious, shuffling the scribbled-on papers and solemnly expressing his love and appreciation for Alan.

"Dear Papa, thank you for taking me to the hardware store. (Shuffle.) And thank you for teaching me how to ride my bike. (Shuffle.) Thank you, Papa, for playing with me. I love you, Papa."

Mitchel's words told me that he would always be able to see his "Papa" in his mind's eye. They had shared meaningful experiences during his young life and those experiences would remain for him in memory.

I had my own memories of Alan and wanted to remember him as the lively, wonderful man I'd known. The night before the funeral service, the casket was about to be closed after the family viewing. A few days earlier, someone from the mortuary staff had asked for a photo of Alan. I had concluded that his handsome face had been altered as a result of the accident. With my kids around me, I walked toward the casket. But midway down the aisle, as the side of his face came into focus, I stopped and turned around. I didn't want to remember him that way.

That's not Alan. That's not him. That's not my hus-
band! I can't do this!

The funeral service was a blur. People told me later
that the chapel was packed. Alan's brother, Howard, of-
ficiated and spoke of Alan's early years, about his de-
votion to Nancy, and how his life had changed when he
married me. His sister, Melissa, sang "Amazing Grace."
Then those who had something to share about Alan
were given an opportunity to do so. Each of my kids
took a turn at the podium, overcome emotionally but
managing to speak through their tears:

Jamee

There was a time in my life when I admired my
mother for her strength and her ability to be a
single mother of four. She seemed to be a happy,
confident, strong woman, and I admired her for
that.

Then there was the point in her life when she
met Alan, and I saw something different in my
mother. Alan brought out qualities in her that
were softer, more trusting, and you could tell—
she was comforted. She had finally found some-
one she could love, honor, and respect: a man
worthy of her devotion.

Although I personally (and selfishly) struggled
with my family moving out of the state of Illinois,

I knew that my personal loss was worth it because my mother had found someone worthy of her love—Alan.

I will never forget Alan and I will always ad-mire him and be thankful to him for giving my mother the love, happiness, and respect that I know she deserves.

Beth

How can I possibly sum up what Alan was to my family? Anyone that truly knew Alan already knows how wonderful he was. Is. So how do I de-scribe the perfect man? How do I let everyone know how he affected us?

He taught us how a man should treat his wife
And how to get the most out of life,
To take pride in the job we do.
He was even proud that I got a tattoo!

I saw him handle situations with class
And laugh whenever he had the chance.

But he really didn't go,
He's everywhere, you know . . .

He's the sun that chases clouds away,
He's the cup of coffee that starts our day . . .

He's the chime that sings in the wind.
He's the sparkle in his grandson's grin.

And I love him.

I love him because he loved my mother.
He loved my nephews, my sisters and my brother.

He always had a smile for us.
He always made time for us.

The love that he shared with my family will
always stay,
In our hearts he'll never go away.

Paul

The biggest thing Alan and I had in common is
that we both loved my mom with all our hearts.
My only exposure to a loving partnership when
I was young was my grandpa and grandma.
When my grandma passed away, that exposure
was gone. My mom and Alan brought that back
into my life. The way they kissed when they parted,
the way they said "I love you" on the phone. The
way they danced to an oldie in the kitchen. That is
how a loving partnership should be. Thank you for
exposing me to that.

Alan inspired me. When I first moved out here from Illinois, I lived with my mom and Alan. He asked me about hiking a fourteener. I couldn't even comprehend trying it, let alone doing it. I wasn't extremely active at the time, so I doubted myself.

Alan would say, "You can do it—you're young!" Long story short, he encouraged me to try it, and I did my first fourteener with him. It was the coolest and greatest experience I'd ever had. Since then, I have successfully hiked seven fourteeners, and on all seven, Alan was with me!

I want to thank Alan for giving me the confidence to do something I never thought I could do. I have every intention of hiking all fifty-four fourteeners, and as a tribute to Alan, I'm going to register my name at the top and write, "In loving memory of Alan Gray." I'll look up to the sky and say, "This one's for you!"

Sarah

How Alan touched my life:
- *He loved and married my mom!*
- *Although he didn't approve, he forgave me and accepted my pregnancy.*
- *He allowed me to move in with him and my mom—but I had to have a plan.*

- *During my pregnancy when I was on intravenous fluids, Alan would come home twice a day to change the IV solution.*
- *He and my mom attended Lamaze classes with me.*
- *Alan used to say proudly, "I never had children, but I'm a grandfather."*
- *Alan was Mitchel's "Papa." He . . .*
 - *taught Mitchel to pick himself up and brush himself off after a fall;*
 - *taught him about respect: "You do not hit women." "Listen to your mom." "Ladies first."*
 - *took him camping, hiking, kiting, sledding and to the playground;*
 - *bought him a dog, our Sadie;*
 - *taught him how to ride a bike;*
 - *allowed Mitchel to work by his side on projects around the house;*
 - *made pizza together as "Tony and Tony" and bowled as "Al and Al, Jr.";*
 - *taught him responsibility, like shoveling snow, taking out the garbage, mowing the lawn;*
 - *took him to the hardware store;*
 - *took him to the pumpkin patch and trick-or-treating every Halloween;*

- *took him out every Christmas to cut down the Christmas tree;*
- *encouraged him to try new things—to take risks; and*
- *during the past few months, got Mitchel off to preschool each day.*

- *Alan held me to a higher standard and encouraged me to better myself through education. In May, I will complete my studies.*
- *He forgave me when I set the kitchen on fire.*
- *He shared stories about his mom and dad and Nancy with me.*
- *Alan worked hard and took pride in his cleaning company. I was his first employee. He taught me about quality and about customer service. He was honest. He cared not only about his clients but, as importantly, about his employees. He had class. He was kind.*
- *He taught me that men should honor me and treat me with respect, like picking me up at the door and paying for the date.*
- *Most of all, he set a high standard by showing me and Mitchel what a good marriage looks like. For example, he danced with my mom in the kitchen, held her, kissed her, and bragged about her. They were friends and companions. They were partners.*

95

They were committed.

- *Alan not only gave Mitchel and me a home, he was the only "father figure" in Mitchel's life. Everything Mitchel needs to know to carry him through life, he learned from his Papa.*

Then instead of reading what he had prepared, Mitchel decided to put his words into song. He crooned his expression of love for his Papa, ending with a sad, innocent expression on his face and the words, "And everyone is sitting here doing nothing."

There's nothing that can be done, Mitchel. Your Papa is gone.

Friends Connie and Sid each spoke of their friendship with Alan. Connie noted Alan's ability to connect with everyone on any level, his respect for life, and the fact that he was genuine, honest and caring. Sid compared their friendship to brotherhood, not by blood, but in spirit—a bond not shared by all.

Finally, my friend, Judy, shared how Alan brought joy to life, understanding what it was all about. She recalled his welcoming disposition when she came to our home, including the great conversations and the laughter she enjoyed there.

In August 2003, a friend and I visited a clairvoyant in the Denver area, just for fun. Generally a skeptic about psychic readings and such, I have never given much credence to anything interpreted at a reading. In fact, I refuse to provide any information up front, and I rarely deny or confirm what I am being told. However, the clairvoyant said things that day that made me wonder if her reading was valid.

First, she said that there was a man named Harold in the room with Alan that day. Pessimistic, I couldn't think of anyone I knew named Harold. Then, it came to me. Alan's Uncle Harold, whom I had not met, had recently passed away.

Then she told me Alan really liked me in the blue dress, that he thought I looked beautiful and sexy in it. Cynical, I said, "I don't own a blue dress." Later, as my friend and I were driving home, it dawned on me that I had worn a periwinkle blue dress at Sarah's June wedding.

She also said that Alan didn't like my hair. Having let it grow out to its natural color, it was now mostly white around my face. I had been debating whether I wanted to color it. Within two weeks following that session, I was asked three times—on three separate occasions—whether I was a senior citizen.

That does it!

I chose to color my hair.

97

The most meaningful and believable thing the clairvoyant told me that day was, "Alan says, 'Thank you for the funeral.'"

You are most welcome! You were . . . are so loved!

CHAPTER 8

The Burial

During the lengthy illness of his first wife, Nancy, Alan had asked where she wanted to be buried. In turn, she had asked him where he wanted to be buried. He responded, "Oakfield, New York," because some of his ancestors had been buried there. Nancy said that if he wanted to be buried in Oakfield, New York, then that was where she wanted to be buried. When Nancy died, that is exactly what happened.

While we were dating, Alan relayed their discussion to me during one of our many long hikes. He said, "Nancy is buried in Oakfield, but I don't know where I will be buried."

Shortly after we married, Alan called me from work one day. His voice cracking with emotion, he said, "You know, my name is on the gravestone where Nancy is buried."

Flustered and unprepared to discuss it, I spontaneously replied, "I have no idea what will happen to

me. I'll most likely be cremated." End of discussion.

I don't want to talk about this.

Secretly, over the ensuing years, I had concluded that should Alan pass away, I would ensure his body was buried next to Nancy's. However, I did not express this until a few months before his death.

In August 2001, Alan and I joined his family for a weekend at his sister Marilyn's home on Cayuga Lake, one of the Finger Lakes in the state of New York. We were celebrating his mother's eighty-ninth birthday. Due to job constraints, we had arranged to arrive late Friday night and depart early Sunday morning.

Twice during our brief stay, I asked Alan if he wanted to visit Nancy's grave, which was less than an hour away. Twice he said no. Instead, he wanted to drive me past the first home that he and Nancy had shared. It was a thirty-minute trip. Following the winding road, I relaxed, taking in the plush greenery that framed our way.

Today seems like a good day to tell him what I have been thinking for some time. We're in New York. It feels right.

Softly, I offered, "Honey, I want you to know that should anything happen to you, I will see that you are buried back here, next to Nancy."

In a foreign (coming from Alan), pompous and self-righteous tone, he retorted, "Well, *yeah!*"

Like a sharp blow to my chest, his reaction sucked the wind out of me.

What was that all about?

I fell silent.

As we neared the house, he asked why I was quiet.

In retaliation to his unkind reaction, I blurted out, "I guess I'll be buried next to my ex-husband!"

Fiercely gripping the steering wheel with both hands, he made a sharp u-turn and angrily proceeded out of town. His anger—something I had rarely witnessed, let alone been the subject of—escalated as he accused me of intentionally hurting him. He was outraged, beside himself! Alarmed, I sat immobilized, holding my breath.

He's going to crash this car.

A couple of miles out of town, he pulled over and jumped out, leaving the car door gaping open. He vented his extreme frustration by walking briskly away from the car and returning fifteen minutes later with a bottle of water in his hand.

As we were making our way back to Cayuga Lake and his sister's home, he offered to drive me, right then and there, to the airport.

In a whisper, I said, "I don't have my identification with me."

Back at Marilyn's house, the silence between Alan and me was deafening. Because of the number of people at the birthday celebration, the distance between us went unnoticed. At one point that afternoon, we excused ourselves for a leisurely walk. Barely speaking, especially

not about that tender subject, we took our time, pur-posely staying away from the others.

Sleeping together was a challenge that night. Alan was 6' tall and I am 5'8". Both of us appreciated the space afforded us in our king-size bed at home. Given the circumstances that night, however, there was plenty of space between us in the full-size bed as we embraced our respective edges.

The tension between us continued throughout our return trip to Denver. I had changed my seat assignment to avoid sitting next to Alan. One thing was certain. We were not going to be able to discuss this highly sensitive subject without help.

Soon thereafter, we met with Sharon, the therapist who had helped us work through some communica-tion problems five years earlier. I was hurt by the tone of Alan's retort. I had been offering him a gift, of sorts, and he had responded with a sense of entitlement.

For Alan, the issue had to do with the commitment he had made to Nancy. He prided himself on being a good husband and a man of his word. This was one last promise he had made to her and he felt obliged to fulfill it.

It was never my intention to convince him to change his mind. I had said what I did because I fully expected to honor his wishes. On the other hand, Sharon focused on where Alan *could* be buried—not necessarily in New

York. During the one session Alan attended without me, he acknowledged that his commitment to Nancy was only good "until death do us part."

In our next session together, he stated that to me. Sharon asked whether I believed him, and I said, "No. Not really. But Alan has never lied to me." Although I didn't feel completely satisfied with the results, we stopped seeing Sharon at that point. We would never discuss it again.

In the early morning hours following the day of the accident, I expressed to Rob my uncertainty about where Alan should be buried. Oakfield? Boulder? That afternoon, Rob returned to the house and informed me that Alan's siblings would stand behind any decision I made about the burial.

"After all," he said, "Alan's commitment to Nancy was 'until death do us part.'"

Alan's words. Alan, are you trying to tell me that you, too, will support whatever decision I make?

The night before the accident, I had worked late at the bank. Darkness had fallen, but I had chosen to leave the shades open on the floor-to-ceiling windows in my office. As I sat at the computer with my back to the windows, I heard a small group of people approaching on the sidewalk. When they passed the windows,

one lady shouted, "Doris, go home!" I turned and caught a glimpse of the side of her face. She looked vaguely familiar.

*Who **was** that?*

Sarah had volunteered to make calls to friends and family from the notification list that I had prepared. At first, I had listed Sharon, our therapist, but then changed my mind. Sarah insisted, though, so she left a voice mail message for Sharon. When she returned the call, Sharon expressed her sympathy. Then, she said, "Doris, that was me Wednesday night, shouting through the window at you."

Upon hearing that, I felt a wave of calm overcome me. It was highly unusual for Sharon to be in the bank's neighborhood. Perhaps God had sent her on that night before Alan's death to remind me of what he had said in her office: "Until death do us part."

Sharon—the witness.

What is significant to us when a loved one passes is personal and often tied to our life experience with the person who has left. That was the case for me when Alan died. Some of the signs from him would have been missed by anyone but me and those closest to me.

During my visit to Colorado in 1992, when Alan and I were dating, Alan had introduced me to hiking mountains. Not only was hiking exhilarating, but spending time with him was invigorating in itself. Even getting caught in a hailstorm as we came off a mountain had been fun and refreshing.

Teasing, Alan would later come to say, "Yeah, that was when we were young and in love."

Whether we hiked high or low trails, invariably we were greeted with wildflowers along the trail or expansive fields of blooms on the tundra. I frequently stopped to admire the delicate, colorful blooms, taking the opportunity to catch my breath and slow my heart rate at the same time. I particularly delighted in the beautiful blues and purples, including the unique columbine.

Authoritatively, Alan routinely declared, "Bluebells." He never claimed to be a botanist by any stretch of the imagination. It was the confidence, the all-knowing attitude he displayed, that tickled me. Over time, even the yellow, red and white blooms got labeled, "Bluebells."

Held in a state of denial after the accident, I wanted no part of choosing a casket or participating in the funeral planning to be held at the mortuary.

If I plan his funeral, I will be admitting that he is really gone.

The kids and Rob and Kaaren went in my stead.

During the meeting, Sarah called from the mortuary to ask about some things she could not answer for me. For example, what kind of flowers did I want covering the casket?

Immediately, I replied, "Bluebells and an array of any other blue and purple flowers," explaining their significance.

I had suggested a burial in the historic cemetery on 9th Street in Boulder, but the representative at the mortuary said it was full. Sarah, Rob and Kaaren were going to drive over to another cemetery in town.

When she got home, Sarah, shaken by coincidence, told me this story: As they turned onto the street leading to Green Mountain Cemetery, they crossed Columbine Avenue and then Bluebell Avenue, two of the four cross streets.

Alan leading the way.

The following day, Sarah and I drove to the cemetery to select the plot.

Days before the accident, Alan had sat at the kitchen table listening to Mitchel and me converse. Mitchel had asked, "Grandma, why do you wear those [wedding] rings on your finger?"

As I finished with my answer, Alan interjected, "And I wear this ring on my finger because I am married to Grandma. She is my wife, and I love her very, very much."

Alan's ring, exhibiting an outline of Colorado's

Front Range, had been handcrafted by Bill Cronin, a jeweler in Boulder. Pointing at one of the mountain peaks on the ring, he continued.

"Mitchel, right here on this mountain, I told Grandma I loved her for the first time."

He remembers. So that's why he chose that ring.

That mountain, known as Bear Peak, was part of the view from the burial plot where Alan was laid to rest. I could envision Alan there, lying on his back with his hands interlocked behind his head and elbows jutting out on either side—his familiar repose—taking in the natural beauty.

There you go, Honey. Enjoy the view.

In addition, there was a daycare facility less than fifty yards from Alan's resting place, just on the other side of the cemetery fence. The melodious voices of children at play filled the air, a reminder of Alan's expansive heart and his love for his grandsons.

My kids knew how I had struggled with the decision regarding Alan's burial. After the funeral, Paul said, "Mom, why not have Nancy's gravestone completed with the date of Alan's death?"

Perfect.

Alan's sister, Marilyn, followed up with the details.

The gravestone was completed with the date of death and the words, "Laid to Rest in Boulder, Colorado" beneath his name.

Nancy will still have a part of him, too.

CHAPTER 9

Connecting with Dad

In January 2002, I had expressed my concern to Alan about my father's failing health. He would be eighty-eight years old in May and, most likely, would not make it through another year. Dad had lived a full, active life, stretching ten years beyond the loss of my mother. He still lived independently in the home that they had shared in Illinois.

My concern was not so much that he was elderly and in a fragile state. I feared living in regret after his death. While I honored my father because he was my father, I had struggled to like him. I explained to Alan that I had never connected with my dad on any level and felt there was a missing link between us. Losing him would be more difficult than losing my mom in that regard. Her passing at age eighty had been difficult, but I had experienced harmony in my relationship with her.

Dad was mostly of German heritage, extremely proud and stubborn. In fact, he seemed quite the chauvinist,

at least toward me, his daughter. Throughout my up-bringing, he had prohibited any expression of emotion, whether it was laughter, tears, or anger. It only took one look of disapproval from him to stop me in my tracks. Not only did I learn to suppress my feelings, but I felt diminished as a human being. I was left feeling un-worthy of an opinion, without a voice.

I quickly learned to deny my emotions and to keep quiet.

It is better to be seen, not heard.

Growing resentful, I became secretly rebellious as a teenager. As an adult, I tolerated him and paid him the obligatory respect. My teenage rebellion turned into a strong desire to prove myself by achieving career success and, eventually, by completing my bachelor's degree at age forty-six. Working hard and smart, I advanced in the financial services field, eventually becoming president of a bank. Although Dad attended my college graduation, not once—not then and not at any other point in my life—did he tell me he was proud of me for my achievements.

When I was forty, having struggled with raising teenagers, I came to realize that he had done his best, within the context of his understandings and abilities. His definition of love was providing for the family, spending time with the family, and loving my mother. However, I never heard him utter the words, "I love

you," not even to Mom. I had eventually concluded that being there was his way of showing love.

I had also wrestled with his prejudice about my size. Not only was I taller than everyone else in my immediate family, I was large-framed. Dad referred to me by my size, humiliating me in front of others when I was a preteen, a teenager, and even an adult.

Once, when I was eleven years old, I was hovering around the table as Dad played cards with guests. Apparently annoyed, he said, "Get out of here, you big ox."

Wishing that I could evaporate into thin air, I slithered into my bedroom and muffled my sobs in my pillow. Until then, I had not been conscious of my body.

*It is better not to be seen **or** heard.*

Another time, as an adult, I was visiting him in the hospital after his triple-bypass surgery. My sister (four inches shorter and petite) and I were on either side of Dad, walking him up and down the hospital hallway. As one of the nurses approached, Dad introduced me.

"This is the big one."

He could have said, "This is my daughter from Colorado."

In my late forties, I wrote him a letter expressing my feelings. I told him it was hurtful when he referred to me by my size, and I asked him to please accept me and acknowledge my more important attributes: intelligence, character, personality and heart. I also asked him to please treat me with respect from that point forward.

In denial, his written response to my letter was, "I've never said or done those things. Why are you doing this to me in my old age?"

The words, "I'm sorry," were not in his vocabulary. However, he never referred to me by my size again.

In many ways, he was a man before his time, partnering with my mother in cooking, cleaning, gardening and canning. My parents were also openly affectionate with each other. They were hardworking people who respected the privacy of others and who had an active social life. Their marriage was a good model for me. Dad loved my mother. That was one of the greatest gifts he gave me.

The second greatest gift came right after Alan's death. Dad, Jamee and Devin had flown into Denver the day after the accident. Dad was weak, barely able to shuffle along, moving at a snail's pace. But nothing could have kept him away.

We all hugged and cried when they arrived. Dad cried, too. Then, he stiffened slightly and said, "Yeah, yeah, I've been through this." His comment triggered those old familiar feelings.

Is he discounting me for being emotional, expecting me to tough it out?

Stepping away, I moved close to Sarah and whispered, "I may need your help in keeping him away from me. I'm not up for this."

Within a couple of hours, though, the energy emanating from Dad seemed to shift.

Immobilized by the grief and in shock over losing Alan, we all sat at the kitchen table for what seemed like two weeks instead of hours. One moment, we reminisced and laughed about Alan's antics; in the next, we sobbed uncontrollably. Dad experienced all of this, too, as he sat next to me.

Then the gift: the connection. Through his tears, Dad said, "I know how much you and Alan loved each other. I've seen the love between you. It was a love like the one Mom and I shared. I lost the love of my life, too."

That statement touched my heart . . . and healing between me and my dad took place.

He understands.

Immediately after that, he glanced at me and shook his head in disbelief, saying, "I thought I saw Mom there."

Tapping my hand on my right shoulder, I tearfully responded, "I think she's sitting right here."

Dad stayed ten days, along with Jamee and Devin. Having him there, not only physically but in that emotionally connected way, was an amazing gift, all the

more so because I was experiencing the worst pain of my life.

This connection with Dad is a miracle. God does work in mysterious ways—perhaps with a little help from Alan in this case. You know how important this is to me, Alan. Thank you.

Little more than eight months after Alan had died, on December 8, 2002, Dad passed away. A few months before he became ill, I wrote him a letter expressing my sincere appreciation for all that he and Mom had given me and for modeling the way. With a grateful heart, I thanked him for loving her, for exhibiting strong values—both in and outside the home—and for giving my kids wonderful memories of time spent with them. And I thanked him for being there for me when Alan died.

Shortly after Dad passed away, I found myself speaking aloud to myself while driving to work. "I don't have anything to prove anymore." The words had escaped my lips without forethought.

Where is this coming from?

In August 2003, I visited a breathwork specialist in Boulder County, one of the many experiential and alternative healing modalities I had engaged in since losing Alan.

I'll try almost anything to feel better.

In one of the breathwork sessions, my residual ill feelings toward my father surfaced. The therapist asked me if there was anything I wanted to say to him. Erupting in tears, I told her that he wouldn't listen anyway. In a visualization exercise, I was able to finally express my feelings by using my voice. Emotionally overcome, I told him how he had hurt me throughout my lifetime. It was both exhausting and cleansing at the same time.

Two months after that, I met with an astrologer for a reading of my natal chart. She stated that she did not promote her psychic abilities. She did, however, note any strong thoughts that come to her while working on someone's chart. While working on mine, she said a male presence persistently repeated, "I'm sorry. Tell her I'm sorry."

Focusing on Alan, I could not imagine why he would be sorry, except that he had left too fast and without saying good-bye.

The following week, the astrologer and I met for coffee with mutual friends. She said, "Doris, I think that male presence was your father. From where he is now, he recognizes the pain he caused you. He is sorry, and he wants you to know it."

At first, that interpretation was difficult for me to grasp. Over time, I have come to believe that anything is possible. Maybe Alan had something to do with

Dad's change of heart and they worked together to promote a healing between my father and me.

I forgive you, Dad.

CHAPTER 10

La Familia (The Family)

In 1998, soon after beginning my job at a community bank in Lafayette, Colorado, I had lunch with a coworker at La Familia, a local Mexican restaurant. From the first, I was hooked on their spicy green salsa and the breakfast burrito, smothered with green chili and cheese.

Before long, Alan and I were going there for dinner on Friday nights. We usually had to wait for a table, but it was always worthwhile. In the meantime, we stood at the bar, taking in the buzz of conversation and laughter and their mariachi band's festive music.

Spending time at La Familia became our favorite night out. At times, it was strictly the two of us. At other times, we met as a group, including Sarah, Paul, Beth and various friends, including Connie, Sid, Dave and Carla. Mitchel was often with us, with or without Sarah. From the time he was a toddler, he would dance around the table, totally uninhibited and oblivious to

117

others. Mitchel's free spirit delighted everyone.

We became such regulars at La Familia that we came to know the restaurant owner, Eleanor, and the servers. Eleanor had heard that Alan owned and operated a cleaning company and asked him if he would clean and buff the restaurant floors once a week. She had recently lost her cleaning company. Alan had purposely avoided taking on any restaurants but agreed to do this one job for Eleanor.

The Friday night before the accident, Alan commented on how much he looked forward to Friday nights at La Familia with friends and family.

Following the accident, I was unprepared to carry on the work of Alan's company. The company was dissolved, literally, overnight. Rob volunteered to notify all of Alan's employees and his clients, including Eleanor at La Familia.

After the funeral service, friends and family members came back to the house for food and drink.

How nice, but where is Alan?

Nothing would ever be the same again without Alan.

I'll never be able to go back to La Familia.

At that moment, an idea came to me. I found Sarah in the living room and said, "We should gather a bunch of people together and go to La Familia tomorrow [Friday] night in honor of Alan. That way, there will be plenty of family and friends to hold me up, to help me get through it."

In the next instant, the doorbell rang. When I opened the front door, I was greeted by a deliveryman holding a lovely flowering plant. Taking the plant, I reached for the gift card. It read, "With Sincere Sympathy. Love, La Familia."

The family.

Friday night, approximately thirty of our friends and family members assembled at La Familia. As we waited to be seated, my friend, Jill, noticed two *Superman* comic books resting on the divider that separated the bar from the dining room. The framed words, "The Funeral Is Over," leapt off the front page of each comic book. Shaken, she showed them to me, pointing to the profound phrase.

"A sign from Alan?" she asked.

Perhaps.

Sarah had purchased the comic books for Mitchel's Easter basket prior to the accident. Apparently, Mitchel had taken them when we left the house that night and had set them on the room divider when we arrived at La Familia.

While it was extremely difficult, I knew that going to La Familia that night was the right thing to do. Eleanor greeted me with a warm hug and the tears flowed between us.

She said, "I was worried you would never come here again."

Nathan, our regular Friday night waiter, took the orders at our table with tears in his eyes, too.

Alan would have approved that we had all gathered at LaFamilia that night. The funeral *was* over. I could almost hear him say, "Now get back to the business of living."

CHAPTER 11

My New Friend Gail

Sometimes ordinary events have extraordinary consequences. Meeting Gail was like that.

A few days before the accident, I met a woman in the ladies washroom of my branch bank. The woman, whose name was Gail, was there to walk through the building and to submit a bid for cleaning services on behalf of her company.

A few days later, she read Alan's obituary in Boulder's *Daily Camera.* Then she received a call from Eleanor at La Familia. Eleanor asked her if she would consider buffing La Familia's floors.

As a normal part of screening potential clients, Gail questioned Eleanor as to why she was replacing her current cleaning company. Eleanor explained that Alan Gray had been buffing the floors weekly, but he had recently been killed in a motorcycle accident.

Gail made the connection. She remembered meeting me at the bank, just days before. Although she did

not really know me and had never met Alan, she was sympathetic.

When I returned to work after my bereavement period, there were several cards and a gift bag sitting on the small conference table in my office. The card enclosed in the gift bag was from Gail. She had written a nice note, but I was ambivalent and still numb with grief.

Who does this woman think she is? I don't even know her!

There was a small pillow-like pouch filled with field corn in the gift bag. It could be heated in the microwave oven or cooled in the refrigerator or freezer, then used for therapy wherever needed on the body.

This is going in the trash.

I would not have given her another thought, but God had a different plan.

Gail's company cleaned the municipal buildings for a small city in Boulder County. One day while making her rounds, she stopped to visit with Sid, the manager of that city's water treatment plant. Sid shared with her about losing his friend, Alan. He asked Gail if she would be interested in purchasing Alan's cleaning equipment. If so, she could call me directly.

In mid-May, Gail phoned me at the bank, reintroducing herself and asking if I wanted to sell Alan's cleaning equipment. This was something I had not

given any thought to, but I was pleased that someone was interested in buying it. She and her family were leaving for vacation, but she promised to call me in a couple of weeks, upon their return.

Two weeks later, she phoned to set up an appointment. She and her husband, Jim, could be at my home at 10:00 a.m. on Sunday.

Before we hung up, I said, "If you are interested in buying any equipment, you will have to take it all. I will not sell it by the piece."

My son Paul called me that Saturday night as I was rummaging through Alan's files to find the original invoices for the equipment. Frustrated, I told Paul that I had no idea what to charge for it all, even if I knew what Alan had paid. He offered to come over the next day before Gail and her husband were scheduled to arrive. He would help me figure it out.

Gail, Jim and their nine-year-old daughter, Bridget, arrived as scheduled, pulling a trailer behind their vehicle. Taking stock of everything, they agreed to purchase all of the items at the price Paul and I had predetermined.

As Jim and Paul prepared to load everything into their trailer, Gail pulled out her checkbook and asked if she could sit at my kitchen table to write the check. We went into the house and I stood near the kitchen counter as she wrote the check. Then she reached into her purse, retrieved a book and held it out to me. She

told me the book had helped a friend of hers who had suffered a similar loss and I could keep it. The book was titled, *Grieving*.

The emotional barrier was lifted as I began to weep.

Why is this woman being so nice to me? I didn't want to let her in, but she is reaching out and touching my soul.

I accepted the book and her check.

Over the next two hours, I sat at the kitchen table with Gail, Jim and Paul, while Bridget and Mitchel entertained each other in the family room. Pouring out my heart, I shared the pain of losing Alan. Pulling photographs from around the house, I showed them wonderful, handsome Alan and told them stories of our life together. They were sympathetic and supportive.

Confessing to Gail that I hadn't liked her at first, I explained that I hadn't wanted to let her in. She had known and understood and asked if I had thrown out the corn bag.

Affirmative.

She offered to make me another one and she did.

During those two hours at the kitchen table, I also confided in them my disappointment with upper management at the bank and the way things had been handled with the cleaning contracts. I told them that Alan had been worrying about the contracts just before the accident. He had wondered if the branch managers were unhappy with his work and simply had not been honest with him.

Gail said she sensed something was amiss when the facilities manager called and said the cleaning services were out for bid. Normally, cleaning jobs go out for bid when the client is unhappy with their current cleaning service. The facilities manager offered no explanation. However, he had instructed her to avoid speaking to Doris Gray because her husband owned the cleaning company currently under contract.

Did he think I would be anything less than professional?

There were twelve branches of the bank, with locations throughout Boulder County and the Denver metropolitan area. With an experienced eye, Gail took in the condition of each branch as she contemplated taking on the new business, wondering how she would staff the jobs.

"While staffing was a real concern," she said, "more importantly, I wondered how we were going to be able to maintain the present level of cleanliness."

She was accustomed to bidding jobs where it was obvious that the cleaning service was not doing a thorough job. But as she walked through the branches, she found something different—a high level of cleanliness.

Honored on behalf of Alan and his cleaning crew, I thanked her for sharing her thoughts with me.

I know you heard it, too, Alan.

Visiting with Gail and Jim, I discovered that they shared Alan's philosophy: pay your people well, minimize turnover, and provide quality service. Gail's

company did not win the cleaning contracts with the branches at that time. Her pricing was higher than the other bids, probably very similar to Alan's.

Gail and I were destined to become good friends. Friends are gifts from God.

Alan, Gail was also a gift from you, wasn't she?

CHAPTER 12

A Cabin in the Woods

Since Alan started his cleaning company in late 1999, we had not been able to get away for a real vacation together. With our conflicting schedules and with Sarah and Mitchel living in our home, it had been difficult to find quality time with each other.

As a result, we made a concerted effort to get away one weekend each month—time for us to simply be alone, together. No schedules. No definitive plans. No interruptions. Our destinations varied, but we usually chose a mountain community like Estes Park, Breckenridge, Glenwood Springs, or Frisco. We often fantasized about having a cozy cabin in the woods, a place to call our own.

Nearly two months after the accident, I thought it would be good to get away for Memorial Day weekend. I made reservations for Saturday and Sunday nights in Frisco. Paul, Beth, Sarah and Mitchel were invited to come along and to bring a friend, if they wanted. Paul

had other plans, but Beth, Sarah, Mitchel and Mark, Sarah's boyfriend, looked forward to it.

As the holiday weekend approached, I began to lose interest in getting away.

It just won't be the same without Alan.

That Friday, I stayed home from work, having been diagnosed with bronchitis. Normally, I would have pushed myself and worked through it, but I lacked the energy and desire to work that day. This was not uncommon since losing Alan.

It was a dark day for me. Not only was I ill, but I was emotionally depleted. I locked myself in my bedroom all day and alternately cried and slept, sinking deeper and deeper into that black hole of grief.

At one point, I was tempted to pull all of Alan's clothes from the closet and bury myself under them, smothering myself in his scent. Instead, I pulled his terrycloth bathrobe from where it hung and covered myself up to my nose.

I need you, Alan. I need you wrapped around me, holding me, loving me.

Only once during the day did I leave my bedroom. Upon hearing the garage door rising, I stepped into the garage. As Sarah got out of her car, I noticed that one of Alan's winter jackets had fallen from the coat hook on the wall to the floor of the garage. Sobbing and emotionally distraught I picked it up.

"Why is Alan's jacket on the floor? Who threw Alan's jacket on the floor?"

Sarah answered cautiously, saying that she must have brushed by it when she had left. From there, I retreated back into my bedroom, back into the familiarity of that darkness, and locked the door behind me.

She thinks I'm losing my mind.

Around 8:00 p.m., I awoke from a deep sleep, eyelids thick and puffy from crying. I went downstairs to the kitchen and saw that no one was home.

They must have gone out to get something to eat.

Although it took a lot of effort to reach out, I called my friend, Cindy. She was training to be a hospice volunteer and had some hospice materials to share with me whenever I was ready.

What does that mean? Am I ready?

She quickly surmised I was having a really hard time and invited me to her home. I left without penning a note.

Cindy greeted me with a warm, long hug and offered me a bowl of homemade chicken soup.

For the soul.

Then we drank hot tea and talked until 12:30 a.m.

I had completely lost track of time. Rushing out the door, I was sure the kids would be worried about me. When I pulled into the driveway, I saw that the entire house was lit up. Sarah had the phone to her ear, sobbing

hysterically as I entered the family room. She had called 911, worried that I might have committed suicide. Of course, the 911 operator would not let her retract the complaint.

Two police officers arrived within moments. They left after being assured that I had not been drinking, was not on drugs, and was not suicidal. (Not wanting to live was different than being suicidal, I had asserted.) Beth left angry, upset with me for having put them through the worry.

Immersed in my own isolated and painful world, emotionally numb, I could not identify with their pain. Sarah reached out to hug me, but I declined.

"I want only Alan to hug me. I need to find a way to get him back here. You can use the condo this weekend. I've already paid for it. I can't go without Alan. I don't want to go without him."

It was 3:00 a.m. before we all settled in for the night. After a sound sleep and a refreshing shower, I came out of my bedroom around noon and joined Sarah and Mark in the family room. They had been debating whether they should go to the mountains without me. Feeling somewhat better, I agreed to the weekend away as planned.

That afternoon, Mitchel and I took a walk on the path that follows Lake Dillon. Then we all played table games, watched videos and ordered in pizza.

Sunday morning, Mark took a hike with Alan's brother, Rob. Rob and Kaaren were staying nearby at their second home in Wildernest, a wooded residential development in Silverthorne.

Sarah, Mitchel and I went out for breakfast in downtown Frisco.

As we were finishing, Sarah asked, "Wouldn't it be nice to have a place up here?"

Her hypothetical question inspired a discussion about how we would decorate a cabin in the mountains: log furniture with a moose, bear and buffalo theme.

After leaving the restaurant, we strolled down Main Street. It was off-season in the mountains, so there were very few people in town. We stopped at a couple of gift shops that were open and, in fun, we held up items that we thought would fit the theme of our cabin.

Further down the street, Sarah noticed that the front door to the Century 21 real estate office was open and suggested we go in. Warren was the one and only broker working that day, Sunday of the holiday weekend. Not a serious shopper in the slightest, I sat at his desk showing little interest. I explained that I might want to purchase a condo in Frisco and uttered a price range I thought I could afford.

Every time he entered the dollar amount into his computer program, one particular condo unit in Wildernest (approximately five miles from Frisco)

came up on the screen. I kept trying to divert him back to Frisco, but he told me that the units in my price range were not built well.

Sarah stood nearby, observing the interaction.

Finally, she said, "Mom, I think we should look at that one."

On the drive to Wildernest, Warren told us that he had not seen the unit, but it had been on the market fifty-five days.

Since about the time of the accident.

He also noted that it was fully furnished.

Ugh. I'll have to throw things out and replace them. I have no energy for this.

The multi-unit building was attractive, but what we saw as we entered the condo stunned Sarah and me.

Upon opening the door, our eyes were immediately drawn to a forty-inch, carved wooden bear exhibiting two separate wooden plaques with the words "Welcome" and "Sarah" engraved on them. One of the sellers was named Sara—her name spelled without the "h."

That's odd. No, wait, there are no coincidences.

As we took in the rest of the condo, we were amazed. The entire unit was furnished with high-end, custom log furniture. All of the electrical outlet covers and light switch covers, as well as the bathroom towel bars and toilet paper holders, were rustic metal configurations of moose, bear, and pine trees. In addition, the light

fixtures, the lamps, and the walls were decorated in accordance with the cabin theme—including bear, moose and buffalo.

Entering the master suite, the first thing that caught my eye was a small wooden bench with the words, "Welcome to the Cabin" painted on it.

You are here. I feel you.

The condo was perfectly furnished. I would not have to dispose of or replace anything.

You remember how much I dislike shopping.

Conveniently, the furnishings also included the bedding, towels, dishes, pans, coffee maker, and other household items . . . right down to the corkscrew. And it was a beautiful retreat, nestled in the woods.

It was as if Alan were saying, with outstretched arms, "Here, Honey, this is for you: a cabin in the woods."

One month later, as I drove up to the mountains for the closing, I fell into a funk.

What was I thinking? I don't deserve this place. Besides, I don't want it without Alan. I wouldn't be buying the condo if I hadn't lost him and received this insurance money. It feels wrong.

The closing was anticlimactic, bittersweet.

It won't be the same without you, Alan, but thank you for my cabin in the woods.

Buying a condo in the mountains had not been the last thing on my mind that Friday before the holiday

weekend; it had never even entered my mind. But there was a reason for it. The "cabin" served me, Sarah and Mitchel well as we worked through the grief of losing Alan. Anticipating a visit to the mountains every weekend was a positive distraction. We were lifted to a higher plane at 9,500 feet elevation—above the chaos and confusion of the metro area. There we began to create new memories with friends and family. The healing process was launched.

A couple of years later, a friend told me that she saw my purchasing the condo as a sign that life was going to go on.

Life goes on whether we want it to or not. Alan, you knew that the cabin would help us with that.

CHAPTER 13

Decorating the Cabin

The condo didn't need much decorating, if any. Ironically, I had a few things at home that fit nicely with the cabin theme. A few others were purchased—with Alan's guidance, of course.

In 1996, Alan and I had taken a road trip through Wyoming and into Montana. We stopped in Bozeman, Montana, to seek out an old friend of mine from my banking days in Illinois. This friend and her family had relocated to Montana in the late 1970s. Her husband had started a business near Bozeman, Big Sky Carvers.

Initially, he had handcrafted duck decoys but had expanded the business to include carvings of moose, bear and other wildlife, as well as some furniture over the ensuing years. By 1996, the company employed close to one hundred people and its products were being sold through Cabella's, L.L.Bean, and many gift shops throughout the United States.

During our visit, we toured the factory. Afterward,

we bought a couple of items in the company's gift shop. These included a large black bear, lying on its back with one leg crossed over the other, and a carved moose. While these items did not fit into our home décor, we had displayed them in our family room. Now they complemented the cabin's décor.

Several years would pass before I came to understand the symbolism of bear and moose. I learned that bear medicine is often connected with awakening the power of the subconscious.

Yes, my subconscious was being awakened.

I also learned that moose is frequently seen as being related to the connection between life and death: the thin veil between them, the ability to connect with the spirits of the dead, and an appreciation for the movement of energy from life to death and back to life again.

Such important understandings . . . and I was beginning to grasp them in ways completely new to me. A sign.

There was more.

A couple of years prior to the accident, I had purchased an expensive, hand-carved clay buffalo at an art gallery in Boulder. The buffalo lay resting on its side. At half price, it seemed like a good buy. The buffalo is one of my favorite animals, probably because it is such a unique looking animal and it represents early American history.

Once I got the buffalo home, it didn't seem to fit

anywhere in the house. After moving it around to various rooms and over a few months' time, I gave up and put it in a storage cabinet.

Will I ever find the right setting for it?

The condo building in Wildernest sat immediately below Buffalo Mountain, which is similar in shape to the hand-carved buffalo, lying on its side. The carving fit perfectly nestled under the lip of the island counter in the condo's kitchen.

Is this part of the master plan, too?

As with the bear and moose symbols, it would be several years before I came to understand that buffalo is considered symbolic of abundance, synchronicity, and manifestation through following the wisdom of allowing things to unfold naturally.

I was learning to let myself be guided by signs and synchronicity. I was learning to trust the natural order of things.

And your abundant love, Alan, was evident everywhere I turned.

One day, shortly after the condo closing, Sarah and I were browsing in the Cactus Patch, a gift shop in Frisco. We picked out a couple of candles and some coasters for the cabin. As we went to pay for our purchases, the elderly man behind the counter visited with us.

Looking directly at Sarah, he questioned, "How was your motorcycle ride? Will you be able to take these items with you on your motorcycle?"

Sarah stared at him in wonder and asked, "Do we look like we came into town on a motorcycle?"

Shaking his head, as if questioning himself, the gentleman responded, "No."

Then he went on to tell us that his son had "gone down" while riding his motorcycle one time and had never ridden again. He also shared a story about a man who was riding his bicycle in nearby Dillon and had been hit by a car and killed. Sarah and I stood in awkward silence, feeling vulnerable and raw, not ready or willing to share the intimate details of Alan's accident.

As I stood there, becoming more and more uncomfortable with the subject, I turned around and looked up. There, over the entrance, was a decorative wooden board with the words, "Cabin Sweet Cabin," on it.

I've got to have that!

As we drove back to the condo that afternoon, Sarah and I discussed our unusual encounter with the store clerk. We agreed that it seemed as if the man in the gift shop was actually conversing with Alan.

*Could there be another explanation? Alan, **were** you there?*

The day I signed the offer on the condo, I had told my sister-in-law Kaaren that I wanted to buy the moose

print known as "A Walk in the Woods" by Stephen Lyman. A couple of days later, Kaaren called to tell me that she had seen the print, matted and framed, for $99 at Sam's Club.

The next morning, I rushed to Sam's Club to make the purchase. Little more than two weeks later, I saw the same print, matted and framed, at an art gallery in Breckenridge. It was "on sale" for $429, marked down from $529.

Alan. Watching out for me and shopping with me.

One last purchase, a decorative board with the painted words, "Live Well—Laugh Often—Love Much," seemed to sum up the life Alan and I had shared.

CHAPTER 14

The Bright Pink Petunia

Near the end of May each year, Alan and I had always worked together to plant flowers in clay pots for the front of the house and the side and back patios. Typically, I chose the flowers and Alan planted them. My favorites included bright pink petunias. We often added other beautiful colors and other plants in the pots as well.

As the season came upon us each year, we religiously debated how many plants should be placed in each pot. Coming from the theory that more is more, I implored Alan to use numerous petunia plants.

"Let's fill up the pots!"

In his calm logic, he consistently debated, "Less is more. The plants need room to grow. They will expand into the space left in the pots."

In order to keep the peace, we compromised by putting in fewer than I wanted and more than he wanted. The flowering pots always looked nice.

The end of May 2002, just two months after the

accident, I told Sarah I was in no mood to plant flowers. "F___ the flowers."

Three days later, as I returned home from work, I noticed that a bright pink petunia had popped up between the sidewalk and the crushed red rock in the front yard.

Petunias are annuals, not perennials.

It had three blooms on it. Sarah had noticed it, too, and we talked about its mysterious appearance.

There must be a scientific explanation for this. Or is it a sign from Alan?

There was a major drought in Colorado that summer. The entire state was on alert and strict restrictions were placed on watering lawns. We were allowed to run the sprinkler system for twenty minutes twice each week, but the sprinkler heads were directed toward the grassy areas, not the sidewalk or the areas covered by the red rock. That bright pink petunia received neither rain nor water from the sprinkler system.

Yet the petunia not only survived the entire summer, it thrived. From time to time, I counted the blooms: 15, 35, 50 and, ultimately, 70. Not once did I pinch back any withering blooms. There were none. The petunia plant continued to flourish as it trailed across the sidewalk. It caught my eye each day when I arrived home from work.

Smiling to myself, I often said aloud, "Hi, Honey."

That same summer, the City of Boulder offered free petunia plants to all of the businesses in an effort to beautify the downtown area. The branch operations manager and I agreed to fill up the pots that sat along the exterior walls of the bank with lots of petunia plants. Because the plants were crowded in the pots, the colorful petunias had no way to grow but straight up. The contrast between the one growing in front of my home and those outside my window at the bank was glaring and somewhat humorous.

Each day, as I entered my office, I could hear Alan saying, "See, Honey, I told you so."

Okay, okay, I get it.

I didn't see the petunia when I returned home from work one day during the first week of September. I stepped out of the car and walked to the spot where it had been growing all summer. Then I saw it. About twenty feet away, a shriveled up vine was rolling gently with the breeze across the yard, like tumbleweed.

Thank you, Alan, for the gift of that petunia all summer—just one of many subtle signs of you in my life.

CHAPTER 15

Dripping Soap Dispensers

Subtle signs of Alan were often evident in unusual places. For instance, a few months after Alan departed, mysterious puddles of soap appeared.

There were five liquid soap dispensers situated throughout the house, one at each of four bathroom sinks and one at the kitchen sink. The one in our master bathroom sat near Alan's side of the double sink. He consistently used three sinks in the house: the one in the lower level bathroom near the garage entrance, the kitchen sink, and his sink in the master bathroom.

I noticed the first soap puddle while standing at the kitchen sink. Conversing with Sarah, who was sitting at the kitchen table, I absentmindedly wiped up a puddle of soap at the base of the soap dispenser. Not five minutes later, another puddle had formed there. Initially annoyed, then curious, I noted that the bottle was half full. The soap dispenser, itself, did not seem to be leaking and it was not overflowing.

Shortly thereafter, puddles of soap had appeared at the lower level bathroom sink and at Alan's sink in the master bathroom. None of the soap dispensers were more than half full. Over the next couple of weeks, I found myself frequently wiping up little soap puddles—only at those three sinks.

Is that you, Alan?

One day, while sorting through some drawers in the master bathroom, my attention was drawn to the dispenser at Alan's sink. The bottle was nearly empty, and there was condensation on its inside walls. In that brief moment, a teardrop of liquid soap slowly descended from the spout. Gasping, I broke into tears, feeling intense peace and love at the same time.

*It **is** you!*

The dripping stopped as abruptly as it had started. It seems I just needed to recognize it as a sign from Alan.

CHAPTER 16

A Really Nice Car

Alan's zest for life did not begin and end with him. It extended to those around him, too—including me. Among the ways that his exuberance wrapped itself around me was Alan's desire for me to have "a really nice car."

The lease on our 2000 Pontiac Grand Prix, the car I drove to work each day, would expire in December 2002. Two days before the accident, Alan and I had talked about whether we would keep the Pontiac or turn it in for another vehicle come December.

Alan said, "Honey, I want you to have a really nice car."

The night before his accident, when I returned home from work late, I found Alan sitting in his comfortable armchair with his feet resting on the hassock.

Pointing toward three colorful brochures on top of the old sailor's chest we used for a coffee table, he said, "I went shopping for your new car today."

147

The brochures touted Volvo, Jaguar and Lincoln. While these were classy cars, I wasn't sure that any of them were right for me.

Alan had modeled the way for having fun and going for it with some of the finer things in life. Early in his marriage with Nancy, he had owned a sailboat. Later, he drove a Mercedes-Benz Roadster. Then it was a Honda Goldwing and, later still, the red hot Porsche 911 Carrera. Finally, it was the Harley.

Knowing how much I loved horses, Alan had encouraged me to buy one. One Christmas, he bought me a saddle blanket. Another Christmas, he bought me a saddle and a bridle. These items were displayed over an old trunk in our home.

Decorative, at least.

Alan teased me about getting a horse.

"You just want a horse so you can control some big, dumb animal! Sweetie, you've got me!"

I never got the horse but knew that I could, if I really wanted it. Horses are a lot of work, and it seemed I would never have enough time for one.

Piloting a small aircraft had been another dream of mine. Alan also encouraged me to follow that dream. Continuing in the Christmas spirit, he bought me a half-day enactment as a fighter pilot one year. What fun! Later, he bought me the textbook and a $100 gift certificate for flight school as another Christmas gift.

With my conservative, practical side dominating my personality, I didn't follow through. Flying is an expensive hobby and when would I ever find the time?

Excuses. I keep finding excuses.

It's possible Alan wanted better for me than I was willing to accept for myself.

The afternoon of the accident, completely unaware of the circumstances, I called Alan's cell phone from the bank and left a message, saying, "I know what I want. I want an Audi!"

Really?

A couple of months after the accident, I paid off the Pontiac lease with the motorcycle insurance settlement. It seemed like the right thing to do—no more monthly payments—but maybe not the smartest.

Fast forward to the first week of December 2002 when I found myself at the Audi dealership in Boulder, looking at the new A-4 model. It was a fine car, but the body reminded me of the Honda Civic.

The salesperson followed up the next day about taking my Pontiac on trade. Their wholesaler was willing to give me $6,000. Just six months before, I had written a $16,000 check to buy out the lease with that insurance money.

No way. I'll keep the Pontiac, thank you very much.

I told the salesperson that I was not interested after all.

The week before Christmas I phoned the Audi deal-ership as I was leaving a meeting at the end of the day.

"Can I test drive a TT today?"

What has gotten into me? I've already decided against a new car. Alan, are you being persistent about me having "a really nice car," even after death?

The Audi TT did *not* look like a Honda Civic. It was a very classy looking little sports car, a true coupe.

The salesman told me they had one new 2002 TT and they would like to sell it before the end of the year. The color: silver.

The ride to the dealership was a surreal experience. It was as if someone else was navigating. After test-driving the TT, without further ado, I made the decision to buy it.

I don't have to be practical anymore. No kids. It's just me now. Wow. I'm stepping outside of the box on this one!

I would keep the Pontiac and when I needed a larger vehicle, I would drive it.

Two days before Christmas, a coworker dropped me at the dealership after work. I felt like one enthusiastic kid! Sensing Alan's presence and his approval, I envi-sioned him dancing a jig and shouting, "She's finally getting it!"

The excitement about the car got me through Christmas that year. While my sadness was to return, the TT did bring me pleasure—and still does. Driving

150

it, I feel grounded and powerful at the same time. It is a great ride—a really nice car.

Thank you, you sweet, sweet man!

CHAPTER 17

Finding a Way Out

Alan knew, before his death, that a part of me wanted to find a way out of my job at the bank. His life was a model of responsibility, coupled with freedom, and while I felt I was demonstrating great responsibility, I did not feel free.

I was close to hitting a wall in my career. My stress level was extraordinarily high with my duties as regional president, which included management of a new, rapidly growing branch as well as oversight of two additional branches and a residential mortgage department cresting a refinance boom.

I'm burning out.

Throughout my career, I had refused to get caught up in the mentality that women were discriminated against in the workplace.

Women carry their own ball and chain—or not.

If I had, I wouldn't have achieved what I did. However, I admit, it entered my mind from time to time that

to be successful in the business world—to stand out—women had to work twice as hard as men. As the only female president in the bank group, I personally developed and maintained the largest loan portfolio at $30 million. No past due loans. No losses to the bank.

A capable, assertive woman, I was labeled as "coming on too strong" when I spoke up or questioned things that could possibly affect the safety and soundness of the bank.

Would a man be labeled that way? No, a man would be considered competent and conscientious. Women should sit around smiling, holding their tongues.

By September 2001, I was on major overload. Having recently fired one of the branch managers under my supervision, I was stretched for weeks, trying to pick up the pieces there and manage my other responsibilities.

No amount of money is worth this. Besides, I'm working for someone else's vision, not my own. What is my vision, anyway?

Nearly defeated, I expressed my feelings to Alan. While I totally supported his entrepreneurial efforts, I also felt trapped in my job. We needed my income. It seemed I had no choice in the matter but to continue.

Alan quickly determined that what he was contributing to the household covered our fixed expenses.

"Honey, you can leave the bank. If you take a job

that interests you and is less stressful, that money will cover any extraordinary expenses. If necessary, we can sell this house and move into something smaller. It will all work out."

That's exactly what I needed to hear. There were options. Brainstorming, we considered what it would be like if I joined him in the operation of his company. I could serve the company in public relations; he would manage the day-to-day operations.

Discussing this option, Alan exclaimed, "I would be so proud to have you working with me in this company! You can be the president."

Leaving my job was not meant to be, at that point, anyway. In January 2002, I received an appeasing, hefty raise and a healthy bonus. The raise, however, was a direct result of upper management hiring a new male subordinate branch manager at more money than I was earning.

Fine. I'll take it. I'll stay for now.

In mid-February, a few weeks before the accident, the problem with the cleaning contracts that Alan held with the branches came up. The bank had hired a facilities manager. Apparently, his first assignment was to reduce cleaning costs across the board.

When Alan learned that the cleaning jobs were going out for bid, he made an appointment with the facilities manager. Alan took him to lunch, showed him the branch contracts, and talked about his customer service philosophy: providing quality service and keeping the lines of communication open.

While Alan's services were not inexpensive, he prided himself on training and retaining good people, a security measure for the branches and his other clients. Alan acknowledged that people are human and, at times, may fall short. Like any service business owner, he aspired to keep his customers satisfied.

The cleaning jobs went out for bid. In the meantime, Alan calculated how his company would be affected if he lost the contracts. Although he held several other contracts, losing the bank's branches would have a financial impact on his company. Quite possibly, he would be forced to lay off a couple of people. But the company would survive and eventually thrive again.

Trying to separate myself, I chose to keep the situation in perspective.

It's business, strictly business.

Until the day before Alan's accident, I saw no reason to take things personally. That morning, however, I met with the managing officer over the regional presidents on another matter. Sitting across from me at his desk, he informed me that Alan would be fired. He told me

not to take it personally, that all of the branches were unhappy.

Astonished that he was involving me—making it personal—I choked on my words as I said, "That will be difficult. I find it hard to believe that all of the branches are unhappy. Alan is thorough and he makes it a priority to communicate with the management team at each branch on a regular basis."

Visibly uncomfortable, the officer bolted from his chair, turned his back to me, and mumbled that it had to do with dust or "something."

Right. Sounds more like sabotage to me.

On the drive back to my branch, I phoned Alan from my car. The officer had made it personal and now I was definitely taking it personally. Alan was my life and more important to me than my job or anyone at the bank. Emotionally upset, I told Alan what was about to come down.

That night, I stayed late at work, typing an impassioned e-mail message to the chief executive officer and copying the managing officer. Something was amiss. It appeared a biased decision had been made on limited information. Although I had tried to look at it as "simply doing business," the managing officer had involved me without first discussing it with Alan. The manner in which this had been handled was unprofessional and seemingly unfair. Alan had done his utmost to keep the branches satisfied.

The e-mail message sent, I phoned Alan as I prepared to leave the branch. At that very moment, he was arriving in Boulder to work at one of his recently acquired jobs. We quickly determined a meeting place: the Target parking lot.

There we held each other in a long embrace, leaning against his truck. Then we sat in my car and discussed the situation. I handed Alan a hard copy of the e-mail message I had sent less than thirty minutes earlier. He had not expected me to defend him. But after reading it, his voice far away, he said, "Thanks."

I phoned Paul once I got home. Sharing my irritation and sadness about what was coming down at the bank, I read the printed e-mail message to him.

Wise beyond his years, he said, "Mom, you are understandably emotional about this, but I highly doubt the e-mail will do any good. They know you love Alan and want to defend him. Will it make a difference? No."

On that note, I promptly left the house and drove back into Boulder to retrieve the e-mail message. (Fortunately, the software at the bank allowed the sender to retrieve and delete an e-mail message if it had not been opened by the recipient.) By the time I arrived home again, Alan was there. In response to his question regarding my whereabouts, I explained what I had done.

The accident occurred the following afternoon. Months later, one of the bank's employees told me that

she had gotten to work early the day after Alan's accident and noticed the contract termination letter lying in the printer tray. Shortly afterward, she read the mass e-mail announcing Alan's passing.

When I told Sarah about the letter, she said, "Mom, Alan simply wasn't going to be here to get that letter."

Interestingly, after the accident, the facilities manager requested the names and phone numbers of Alan's employees on behalf of the new cleaning company.

I thought they weren't doing a good job.

Disappointed by the unprofessional manner in which Alan had been treated, I wanted out of the bank more than ever. My respect for management at the corporate level had waned. Even if Alan had lived, with him losing those contracts, I would have been looking for a way out.

Alan will guide me. He knows.

Admittedly, it was beneficial to have the job, a familiar place to be during the year following the accident. But the passion for my work was gone.

Meanwhile, insurance monies started to roll into my life. The temptation to rip the first check into shreds was overpowering.

Fuck this! I don't want this money! It's paper! It's not Alan! I want my husband back!

During the initial bleakness, I turned to an attorney who sat on the bank's Board of Directors. Though his specialty was in wills and estates, I asked if he would represent me with the insurance companies.

I want no part of this.

Over the next couple of months, one of my customers (also an attorney), stopped by my office more than once to convince me that hiring an expert, an attorney who handled personal liability cases, would be in my best interest. He gave me the name and telephone number of his trusted friend and peer, Bruce, who practiced in Denver.

I dialed the number, thinking that his name was vaguely familiar. I found Bruce to be a warm and sensitive individual. As my memory began to unfold, I realized that this same attorney had helped Alan obtain a settlement from a company that had severed an employment contract in 1999. They had never met but had communicated by fax and phone throughout the short process.

I'm supposed to work with this man, too.

Bruce asked for copies of all of my insurance policies, including those covering the house, Alan's motorcycle, and our cars, as well as our umbrella policy. Based on relatively new case law, he determined that I was eligible for a settlement under the uninsured/underinsured portion of our automobile policy.

The settlement was sizable and totally unexpected. Bruce could easily have offered to take the case for one-third of the settlement plus expenses. I would have agreed to that, believing it to be a standard arrangement. Instead, he was confident that the insurance company would settle and charged me only for the few hours he worked on my file.

This man is a gift. Has Alan brought him to me to help me put together some money so I can leave the bank?

Still, my heart was broken. I was mentally, emotionally and physically depleted.

If only I could sleep for three weeks straight.

Plodding through each day, I considered finding a way out of my job, a way to make it without the standard paycheck.

Paul and I discussed my escape options several times over weekly dinners the year following the accident. He expressed concern.

"Mom, what about your retirement plan?"

"I would have to work another eleven years to be eligible for it." Determined, I continued, "What if I don't live that long? Paul, I know God will show me the way out. And when it comes to me, it will hit me between the eyes. There will be no doubt. Not a shred of doubt."

And there wasn't.

By osmosis, I had learned a lot about real estate investing from several of my bank customers. It appeared to be a relatively safe and profitable venture. In 2001, Alan and I broke into real estate investing using equity in our home to purchase our first rental property. We caught the fever and chose to liquidate some of our declining-value retirement funds to purchase three more houses. It was exciting!

We were great partners in every sense of the word, including this real estate venture. Alan was knowledgeable and handy. He was capable of determining whether he could fix a problem or if he should turn it over to a professional. With my lending experience, I was comfortable handling such things as screening tenants, reviewing applications, negotiating rents, preparing the leases and collecting rents. It was a balanced working partnership.

Less than a year after Alan's death, I attended a luncheon hosted by one of my bank customers, Bob. He and his father owned and managed several residential rental properties that they had accumulated over many years. When Bob had first learned about our initial real estate investments, he had commended me for stepping outside the banker-mentality box.

After lunch that day, Bob walked me to my car.

"I have something for you," he said as he handed me the book, *Rich Dad, Poor Dad* by Robert Kiyosaki.

With little effort, I quickly absorbed every word in that book. Its contents hit me between the eyes, as the author spoke about the rewards of real estate investing.

There. That's it! No doubt.

Fuzzy-brained due to my emotional state, I had not been able to see the obvious fit for me—until then. Over the next several weeks, I put contracts on a few more properties. These properties, combined with those Alan and I had purchased, would constitute a nice portfolio and a positive cash flow.

I'm carrying out what Alan and I started together.

As my real estate broker, Karla, and I did the final walkthrough on the last property, I noticed lavender creeping myrtle growing near the front entrance.

Bluebells! A sign that Alan is giving me his blessing on this final purchase and on my decision to leave my job.

After the closing, Karla and I met with my mortgage broker, Jodi, at a local bar and restaurant. We sat outdoors and each ordered a glass of wine. Raising our glasses, we toasted Alan.

Freedom!

CHAPTER 18

Mitchel Gets a Dad

Soon after Sarah moved to Colorado, she had told me, "Alan gives me hope." She had quickly concluded that Alan was not only a good man, but an exemplary husband, as well.

Alan wanted a good man and a good husband for Sarah, too. He was distressed when Sarah drove to meet a date, instead of allowing the man to pick her up at the house.

"Sarah is a prize to be won. This is true for Jamee and Beth, too. Any worthwhile man should go out of his way to pick them up at the door."

Sarah did meet a worthwhile man before Alan's death.

In May 2001, Sarah met Mark through mutual friends while he was visiting Colorado from Syracuse, New York. They began dating when he relocated to Denver that July.

Hearing impaired since early childhood, Mark read lips, spoke articulately, and also knew American Sign

Language. Sarah was pursuing a degree as an American Sign Language interpreter. They shared a common language and had a common bond.

Mark took to Mitchel instantly. His positive energy and playfulness appealed to Mitchel, and they became fast friends.

Neither Alan nor I had gotten to know Mark very well before the accident. Although Mark had been seeing Sarah regularly, they were not yet serious. Alan's passing would change that.

The day following the accident, I sat alone in my bedroom, silently beseeching God.

Why? Why did you take Alan? I need him. Mitchel needs him! What about Mitchel?

In that still, small voice, God said, *Mitchel has Mark now.*

As it turned out, Mark was there for us in every way after the accident, a bright light displaying heartfelt compassion and humanity. He grieved with us and for us—especially for Sarah and Mitchel.

It seems that when there is a death or other life-altering event in a family, the character of a person shines through—either positively or negatively. Mark's character shone through as strong, compassionate and full of integrity. The entire family came to love and respect him.

Alan, I believe this is the worthwhile man you wanted for Sarah.

From that point forward, Mark and Sarah's relationship was sealed. They became engaged little more than six months after the accident. Mark asked for my blessing the night before he planned to propose. Ecstatic, I did not hesitate giving him my approval.

Mitchel would have a wonderful father, a man who would carry on what had been started by Alan. Mark would be good to Sarah, and he would be an example to Mitchel, teaching him to embrace life and to respect women.

A gift. An answer to prayer. With a little help from Alan?

They would be relocating to Syracuse, New York, where Mark had been raised and where a job awaited him.

Two weeks before the wedding in June 2003, Sarah said, "Mom, I'm thankful for the way Alan touched my life. He was an excellent role model. Without his example, I might not have held out for someone like Mark. Mark is a lot like Alan, and I know how fortunate I am."

A few months later, when I visited Sarah, Mark and Mitchel in their new home, Mitchel said, "Grandma, I have two dads now."

He's thinking of his biological father and Mark.

"Papa and Mark."

Alan, did you hear that? Of course you did. Mitchel will never forget you.

CHAPTER 19

The Tattoo

Though sporadic, signs from Alan continued. But while Alan could leave signs of himself—sometimes in the form of welcomed information, sometimes in the form of little nudges, and sometimes just as comforting reminders that he was still with me—it was always up to me to make sense of them.

In May 2003, Sarah, Mitchel and I were driving to the cabin when I got pulled over for speeding. The state trooper said she clocked me going through a construction zone thirty miles per hour over the posted speed limit, just west of the Eisenhower Tunnel.

I had not seen the speed limit sign and had been traveling with the flow of traffic. Mine was the vehicle stopped. The trooper ticketed me and told me that I must report to the Summit County Court on August 6th, or a warrant would be issued for my arrest. The ticket was a six-point violation that would appear on my driving record, a serious offense in the state of Colorado.

The day before the scheduled court appearance, I drove to the cabin again. It would be a relatively short distance from Silverthorne to Breckenridge where the courthouse was situated. As I was winding through the mountains, traveling west on I-70, I began to worry about the potential outcome.

How is this going to affect my driving record? What will this cost me?

I beseeched Alan. "Where are you, Alan?" I asked, aloud. "I need you! I haven't seen signs of you lately."

Once at the cabin, I thought about getting a massage treatment that afternoon to ease the tension in my body. I opened the telephone directory and my eyes were immediately drawn to a listing for "Inexpensive Spa Treatments."

Inexpensive. Cheap. Poor quality.

I quickly skipped over that one.

After dialing four other numbers and hearing an automated voice mail greeting, I called Inexpensive Spa Treatments. A man answered and I asked if he had any openings for a massage that afternoon. After I agreed to a 5:00 p.m. appointment, he took my name and telephone number.

Upon hearing my name, he inquired, "Did your husband just call here?"

"No. My husband is deceased."

"Well, some guy by the name of Gray just called here."

Alan, was that you?

"Perhaps I'm supposed to come there today," I replied.

Having experienced several massages, I preferred the breadth of a man's hands and the firm pressure and strength associated with them. One of the greatest things about getting a massage, however, is that I can get lost in the wonderful, respectful silence, drifting into never-never land.

This massage was different. Nick, the massage therapist, began talking gently to me, and I found myself engaged in conversation throughout the massage.

Nick shared with me that his sixteen-year-old son had been killed in an automobile accident a few years earlier. The driver had also been sixteen.

Then I opened up about Alan's fatal accident and stated that the young man driving the car that hit him had been sixteen years old. Thoughtful, Nick quietly said that maybe he wouldn't get the motorcycle he had dreamed about. I assured him that it wasn't about the motorcycle. Alan had been passionate about owning and riding his Harley and if Alan had to go, at least he had gone out with dignity, doing something he truly loved.

"Alan was my alter ego. I was a conservative banker. He, on the other hand, had stepped out of the box not only by purchasing the Harley, but by suiting himself

with all the leathers available to riders, getting his first tattoo at age fifty-one and piercing his left ear.

Alan was a wonderful husband, always supporting me in my every endeavor. In turn, I had loved him and encouraged him to embrace life and to be the man he wanted to be. In fact, when Alan first spoke about getting a tattoo, I called his bluff by giving him a gift certificate to a tattoo parlor not far from our home in Westminster. Shortly thereafter, Alan came home with a tattoo on his left upper arm—a large, colorful eagle."

"Really?" Nick asked. "What did the eagle look like?"

"It was diving for its prey."

As he raised his shirtsleeve, Nick asked, "Like this one?"

He had gotten the exact tattoo on his upper arm several years before, somewhere in Pennsylvania.

Amazed at the coincidence, I said, "I'm definitely supposed to be here today."

Alan, thanks for showing up. I knew you would.

The following day, I appeared at the courthouse and learned that the charge had been reduced to a four-point violation.

Did you have something to do with this, too, Honey?

After paying the $116 fine, I left the building, my thoughts turning to the massage I had enjoyed the day before.

Periodically, over the next nine months, I continued

to see Nick for massages. Twice, when he moved his business to other locations, I followed him. Each time, I not only looked forward to his firm, soothing touch but also to the conversation and the laughter we shared.

There seemed to be a real connection between us.

Is there something here of which I'm not totally aware?

Nick recalled things we discussed and frequently referred to them in subsequent sessions. I liked the attention and his sense of humor. He was filling some need deep inside me.

While not highly educated, Nick was inherently intelligent. At forty-three, he had evolved in many ways. Having been raised in an abusive environment, he left home at a young age. He talked at length about himself, sharing his life lessons and telling stories about his family— stories of regret, sorrow, joy and the enlightenment gained as a result of his experiences. He spoke about his insecurities and lack of confidence. In turn, I told him that he undervalued himself. Our friendship grew.

As I got to know more about him, I learned about his rocky relationship with a long-term girlfriend, the mother of his nine-year-old son. In some ways, Nick also seemed unstable and, perhaps, irresponsible. These things didn't bother me at the time. Apparently, I was hungry for the attention and wearing blinders.

Nick was eleven years younger than me and a good-looking man, about six feet tall and physically buff. His

eyes were dark brown, matching the color of his hair, which was pulled into a ponytail at the nape of his neck. (I had teased Alan about growing a ponytail, something I like on *some* men.) He had nice hands, too. I always notice hands.

Skilled in massage therapy, Reiki, reflexology, aromatherapy, flotation tank therapy and sound therapy, Nick continued to investigate and expand into alternative healing methods. Before becoming a massage therapist, he had worked in the housing construction field for close to twenty years. During a break from his girlfriend, he offered to work on my real estate properties if needed.

Taking him up on his offer, I asked Nick to do some work in my condo: level my dishwasher, replace the kitchen faucet, replace the showerhead in the master bathroom, align the closet door in the guest bedroom, and make other minor adjustments throughout. When he came to my condo for the day, he did an excellent job with everything on my list. We had fun bantering with each other and laughing all day as he worked and as we sat eating lunch. Secretly, I didn't want him to leave.

I feel alive today. I've been so lonely.

When he had finished his work, I helped him out to his truck with his tools and the leftovers from lunch. Standing near the back of the truck, Nick opened his

arms, and I flew into them for a warm, wonderful hug. Then, flustered, I turned and quickly made my way back into the building.

When I thought of him in a romantic sense, I got weak in the knees.

Are we supposed to be together?

Then it came to me that we had met on August 5th, the same day Alan and I had first met in 1991.

What does this mean, if anything? Alan, are you trying to tell me something?

How would people react when I told them how we first met? "Yeah, I met Nick and within three minutes, he had his hands all over my body!"

Neither of us broached the subject, but there was definitely a lot of energy in the room when we were together. In fact, it became rather intense and awkward at the same time.

We met a few times after he had worked in my condo. As usual, the massage was excellent; the conversation was, too. Then he told me that he was back with his girlfriend, mostly because he needed to be near his son.

I can respect that. It's definitely where you belong.

Soon we started to explore the possibility of venturing into business together. I would finance small construction projects; Nick would build them. He owned five acres outside of Fairplay, about an hour south of

Breckenridge. We drove to his property one Saturday afternoon. The land and the improvements would be my collateral.

Seems feasible.

After each encounter with Nick, I began to experience a certain level of withdrawal. It was like there was warm sunshine in the room when I was near him. The hours that followed seemed cloudy, cold and empty.

What is this? Why am I doing this to myself?

During what was to be our final interaction, Nick asked if I would consider buying him a new truck.

Whoa.

"That's not going to happen." I continued by telling Nick that I didn't think it would be a good idea for us to be in business together. I had grown fond of him, making it difficult to be around him.

He responded, "Okay."

I wished him much happiness in life and we said our good-byes.

Getting to know Nick had been a good experience for me. I had appreciated the attention, especially the great massages. Mostly, though, I had learned that I could laugh again—and I could feel again. Literally and figuratively, Nick had touched my life.

But sometimes a tattoo is just a tattoo. Had Alan led me to Nick? Perhaps. I needed the relaxation that a massage could provide that first day. And I needed to

know I could still respond to male attention. But the tattoo, meeting on the same day that Alan and I had met—these coincidences did not necessarily mean that I was meant to be with Nick, either personally or as a business partner. I needed to apply discernment and had done so.

And Alan was there watching over me. He wasn't going to let anyone take advantage of me.

You know how vulnerable I am right now. Thanks for being there for me.

CHAPTER 20

Grace in the Form of Gracie

"Did you hear Allison is pregnant?" asked Kaaren.

We had been sipping coffee and catching up on things at a sidewalk café in Boulder when she gave me the good news. I hadn't heard, but I was sure that Alan was smiling in heaven.

While Alan was fond of his six nephews, it was his niece, Allison, who held a special place in his heart. As I came to know her, I had grown fond of her, too.

"When is she due?"

"Alan's birthday," Kaaren replied.

Instantaneously, my eyes filled with tears. Kaaren's did, too. After a moment, I shook my head in wonder.

"I don't know why I reacted that way, except that I recently read a story about a young couple that had been trying to get pregnant. The baby was born on the young woman's deceased father's birthday. It's not the same, though, because they had been trying since they had gotten married, four or five years earlier."

Kaaren replied, "Allison and Willie have been trying to get pregnant since they got married."

That had been three years.

On the drive home, I was awestruck. Envisioning Alan with his buddies in heaven, I could hear him say, "Doris will get this. She's one smart lady."

Through family members, I later learned that Allison's anticipated due date was November 10th, not the 12th, which was Alan's birthday. The week of his birthday, I sensed his presence.

Kaaren phoned me the morning of the 12th to see how I was doing. As we chatted, I sat on the edge of the bed in the master bedroom, facing an interior wall. Suddenly, I noticed a sign from Alan: a colorful rainbow on the glass-covered print hanging on that wall. There was no exterior wall in the master bedroom. There were windows, but they opened into the atrium on the backside of the house. There was no obvious explanation for the appearance of that rainbow.

After we ended our conversation, I stepped into the shower. Standing there, the stream of hot water gliding down my back, I felt a large, cold mass of air next to me.

Where is that coming from?

Aloud, I asked, "Alan, is that you?"

Then the cold disappeared as abruptly as it had appeared.

Showering together, just like old times.

It was two days later when I learned that Allison had delivered a healthy baby girl just forty-five minutes after midnight on November 12th. She and Willie named her Gracie.

A derivative of Grace. What grace to have you arrive on Alan's birthday.

CHAPTER 21

Dancing in the Kitchen

One of the things I sorely missed after Alan's passing was dancing in the kitchen with him.

My friend, Carla, had repeatedly invited us to take country dance lessons with her and her husband. Alan rejected the idea at first, but eventually acquiesced. We quickly caught the fever and immersed ourselves in the Waltz, the Cowboy Cha-Cha, the Two-Step, the Triple-Step and the West Coast Swing.

Grateful for those fun times, we gracefully handled the power struggles on the dance floor with Alan reminding me that the man is supposed to lead. At times, we doubled over with laughter at our missteps. Alan beamed from ear to ear when we debated the correct movement and the instructor sided with his interpretation.

After the third lesson of basic country dance steps, Alan said, "I am having so much fun! Thank you for being persistent in getting me here."

The lessons were held on Friday nights and we practiced at home whenever we could. We hit the Denver dance clubs on Saturdays, often meeting up with our friends.

Our social dancing activities eventually lessened, but we kept the spirit alive by frequently breaking into dance around the house, often in the kitchen. Alan would spontaneously grab hold of me, and we would sway and swing to whatever music was playing on the stereo. If Mitchel was home with us, Alan would scoop him up and we would all dance together in a group hug.

How I long to be gliding across the dance floor—or the kitchen floor—with you again.

When my sister and her husband came to Colorado for a visit the year following Alan's death, we went out each night for entertainment. On the final night of their visit, we went to a karaoke bar not far from my home.

Sitting at an elongated table with chairs on one side, we faced the stage and the dance floor. Next to me, on my right, was a nice looking man dressed in motorcycle leathers. His name was Ray. He had ridden his Harley to the bar that evening.

"Be careful out there," I encouraged, "especially riding home after downing a few beers."

Appreciative, he responded, "Not a problem. I live less than five miles from here."

Alan's accident occurred within two miles of home.

Then I told him about Alan, his love for the ride, the accident that occurred close to home . . . and, ultimately, about my loss. Compassionate and kind, Ray listened intently.

In turn, he shared stories about his wife and children, bringing out his wallet to show me photos. He was proud of his family.

While conversing, we each moved slightly to the music playing in the background, cognizant of its beat.

"Would you like to dance?" Ray finally asked.

Before I knew it, we were on the dance floor, continuing to dance for much of the evening.

Alan, did you have something to do with this?

A couple of months later, Jamee flew into Denver and we drove to Santa Fe to meet friends from St. Louis for a long weekend. One evening after dinner, we stepped into the bar area of the restaurant to listen to the live music. The band was playing salsa, something new and different to the four of us. Feeling good from the wine, the food, the pleasant company and the music, a natural smile graced my face.

As I made my way to the washroom, I noticed a man standing at a cocktail table watching me. When I left the washroom, he followed me to our table and asked

me to dance. On the dance floor, he taught me salsa, reminding me throughout the evening that "it's all in the hips."

His name was Greg and he was a local resident. He joined us at our table between dances. Several times while we were dancing, he leaned toward me to say, "You're cute!"

How funny! That's what Alan used to say.

By midnight, I was worn out from all the activity and Jamee and the others were a bit weary from boredom. As we left the restaurant/bar, we chuckled about my "success" in attracting a dance partner for the evening, while they all sat at the table without so much as an offer.

Alan, did you have something to do with this one, too?

Because I have never really cared for the bar scene, those were the only times I found myself out dancing after Alan's death. Both times, I felt Alan was giving me a gift. Perhaps he was dancing with me in spirit.

I still dance in the kitchen—alone now, imagining Alan spinning me around the floor.

CHAPTER 22

The Unwelcome One

While growing his business, Alan had solicited the cleaning contracts of almost every branch within the bank group where I was employed. He placed competitive bids one branch at a time, slowly gaining the confidence of each manager and eventually earning most of the cleaning contracts.

One day, he received a phone call from Richard, the operations manager at the Denver branch. He asked Alan to place a bid for cleaning services.

Alan had purposely avoided soliciting their business because he wanted to keep his cleaning crews near and around Boulder County, but he consented to submitting a bid.

The president and my colleague, Steven, had begrudgingly greeted Alan the day he came to measure the branch. Steven expressed disdain with having hired and fired three cleaning companies in the past year. Later, Alan and I agreed that Steven's frustration and

experience with the other cleaning companies should have been Alan's first clue.

Richard negotiated the bid down and offered Alan the job when he accepted the lower rate. As usual, Alan worked the building for the first few weeks and then delegated it to two of his best people.

Steven was demanding about the work and had Richard call Alan frequently to complain about the cleaning job. For example, he cited dust in the indentations of the paneling. Though cleaning those was not part of the contract, Alan had his crew detail them and did not charge for the extra time.

Alan also received complaints via Richard about the polished granite flooring. It was smudged. There were streaks. Alan researched cleaning methods. It was like dealing with glass, a glass floor. He had his crew rinse the floor several times each night. This job was not profitable.

A few weeks before Alan's accident, Richard called to complain about the granite flooring again. Richard said that Steven wanted to see Alan right away. Within a short time, Alan dropped what he was doing and went to the branch.

As he entered the lobby, Steven approached, grumbling under his breath as he looked through Alan and passed by him. Alan turned to speak to him, but Steven brushed him off.

Alan was typically optimistic and little bothered him, but Steven's rude behavior disturbed him. After he left the branch, he phoned Richard and told him he never wanted to deal with Steven again. If there were issues, Alan would speak directly with Richard, not Steven.

That night at home, Alan shared his frustrations with me. It was no wonder the branch had gone through three cleaning companies in the previous year. It seemed that the problem ran deeper than any issue about cleaning.

Then the accident occurred. With the funeral approaching, I figured Steven would show up. But I didn't want him there. He had disrespected Alan while he was living. Why pretend to respect him in death?

Paul volunteered to call Steven the morning of the funeral. First, he introduced himself and then he told Steven that I didn't want him at the funeral. He had been disrespectful to Alan and I didn't want him to attend the service.

Steven said that he had liked Alan and respected me.

Paul said, "I know you want to do the politically correct thing, but if you really respect my mother, you will respect her wishes."

Alan, I'm doing this for you. It matters to me.

Steven did not attend the funeral.

In that Steven and I were colleagues, it was inevitable

that our paths would cross at meetings. Without fail, we were always professional and polite.

When I resigned my position at the bank approximately one year later, upper management sent a mass e-mail to all bank employees, announcing my "retirement." In response to that e-mail, Steven sent me a message saying he knew he wasn't one of my favorite people but wanted to give me his best regards. He stated that I would be missed at the bank and wished me well in my future endeavors.

I can ignore the message. I don't have to respond to it.

Choosing to reply, I wrote that I would accept his kind words and good wishes if he would first apologize to me for being offensive to my husband. At first, he acted as if he didn't know what I meant. Later, after I had clarified myself, he sent an apology.

Alan, have you been working on Steven? Apology accepted.

Paul's fiancée, Rachel, worked at the Denver branch, acting as Steven's right hand much of the time. Steven appreciated Rachel and supported her in every way. Rachel had not known her own father and looked to Steven as a father figure.

Given Rachel's relationship with Steven, he and his wife were invited to Paul and Rachel's wedding. Paul

asked if I was going to have a problem with that. Reassuring him, I affirmed that their wedding day was not about me.

Rachel considered having Steven walk her down the aisle, but she chose her twin brother instead. However, she did ask Steven to give a champagne toast at the reception, and he agreed.

Following the wedding ceremony, I sought out Steven and his wife. After hugging his wife, I offered my right hand to Steven. He countered by stretching out his arms and embracing me.

Was that you, Alan, showing me a forgiving heart? From your vantage point, everything must seem trivial now.

In retrospect, I can see that my anger might have been displaced. I've learned that anger is one of the many emotions that one experiences during the grieving process. Steven was apparently an easy target for my anger at that time, and forgiving him was a part of my own healing process.

Grace and wisdom from above.

CHAPTER 23

A Bad Investment

When Alan and I caught the buy-investment-real-estate fever in 2001, a fellow investor warned us, "Buy one, and you will be planning your next purchases."

It was our second real estate investment that actually gave us the fever. A husband-wife realtor team had tipped us off about a great opportunity. Townhouses were being sold in a new development in Longmont, east of Boulder and north of Denver. They were selling like hotcakes. Put $2,000 down to secure the price, wait ten months for the building to be completed, and then sell it for a profit.

Alan and I visited the models and particularly liked the end unit—enough to live in it ourselves. We considered our options: sell it upon completion, lease it for one year or, possibly, move into it. For merely $2,000 down, it seemed like a safe investment.

Within sixty days of signing the contract, we had to choose and pay for any upgrades over and above the

standard-issue cabinets, carpeting, paint, and fixtures. Attempting to minimize the expense, we were careful in our selection. Among other things, Alan wanted to drywall the garage and I wanted built-in cabinets in the utility room. The total came to $8,000 in upgrades. Our investment had become $10,000.

Initially, the developer had told us that the closing would take place in February 2002, almost a year away. With the escalating real estate values at that time in the Denver-Boulder metro areas, Alan and I believed we would realize a nice profit.

Then came the 9/11 terrorist attacks and time stood still, not only in Longmont, but across the nation. Real estate values leveled off or bottomed out.

In November, the developer called and told us the closing would take place in early December. Upon hearing this, I made phone calls to a few business acquaintances who owned investment properties in Longmont.

Properties were being leased for less than in prior years. One business acquaintance had purchased the three model units in that development. The model of our unit had recently sold for $15,000 less than the asking price.

After crunching the numbers, Alan and I took a serious look at our options. If we sold the unit, we likely would not profit. If we leased it, we might be forced to

subsidize the payment by $300 to $500 per month. In all probability, it could take up to five years to break even.

In addition, given the market throughout Colorado, selling our home and moving into the new townhouse was impractical. In the final analysis and in a concerted effort to cut our losses, we walked away from the deal.

In July 2004, I met Barbara while volunteering at Real Choices Pregnancy Care Center in Boulder. After spending the entire day working together, we became fast friends. We were surprised to discover that we lived close to one another in Westminster.

The following weekend, Barbara and I attended a fundraiser together and went to dinner afterward. She listened with compassion as I shared with her about losing Alan, the bouts of loneliness, and how difficult it was to carry on. After my divorce, I had soured toward men. What I had experienced with Alan had made me realize that there really was such a thing as true, unconditional love. Additionally, I shared with her some of the many signs of comfort I had received from Alan since his death.

I told her I felt open to dating again, sure that I would receive a sign. While I was not desperately seeking a man, God would know when the time was right.

On the drive home, she mentioned that her good friend, Ralph, had been widowed since early 2004. Ralph attended her church.

I wonder if I will ever meet him.

Less than one week later, Barbara called and asked me if I would like to meet Ralph. While she thought it was too soon for him to be dating, Ralph had confided in her husband that he was ready to meet women.

Oh, dear. I'm being called on the carpet. Am I ready?

I would have to think about it.

A few days later, I told Barbara that I was open to meeting Ralph for coffee. She could give him my telephone number.

Barbara had not gotten around to giving Ralph my number when I found myself, at the last minute, with an extra ticket to an Emmylou Harris concert in Denver. The single girlfriends I called had other plans.

What have I got to lose?

Two hours before it would be time to leave for the concert, I pulled Ralph's number from the phone book and called him. He eagerly accepted the invitation and offered to pick me up.

He sure is spontaneous!

While dressing, I started to panic.

What am I doing?

I lay on the bed, fretting and praying, feeling sick and holding my stomach.

Alan, I'm scared. Please, please, come with me.

I managed to pull myself together before Ralph arrived.

We had time to visit during the drive into Denver and while waiting for the concert to begin. At first, we covered the standard getting-to-know-you subjects.

This is so awkward.

Ralph mentioned that he and his wife had purchased a townhouse in Longmont almost three years earlier. He went on to say that the townhouse had been under contract before it was built, but the buyers had walked away from their $10,000 investment just before closing.

Really!

"That could have been my husband and me," I said.

Ralph asked if the address was 4023 Dell Street, but I wasn't sure. Throughout the evening, I recalled some of the upgrades we had made and asked him about them. No upgraded carpet? Right, but there should have been. Dry-walled garage? Yes. Cabinets in the utility room? Yes. Door on the master bathroom closet? Yes.

Coincidence?

After the concert, we stopped for coffee. Ralph verbalized the deep grief he had been experiencing. The first few months, he had been busy with paperwork. During the past two or three months, he had been escaping into the restroom at work to grieve.

While he expressed his pain at least three times, in the next breath he proclaimed, "I'm ready to move on."

It's just not that simple, Ralph.

I empathized with him, but I felt an uncomfortable choking and smothering sensation around my chest and throat.

This guy is in a big hurry.

As soon as he dropped me off at home, I went to my file cabinet to look for the address of the property in Longmont and found the file tab "4023 Dell."

Oh, dear! What does this mean? Am I supposed to be with this man? I'm not even attracted to him, and I definitely don't want to be the object of his desperation!

Ralph phoned the following Monday and left a voice message asking if I wanted to join him at a Nora Jones concert, three weeks out.

I love Nora Jones, but I was uncomfortable with the prospect of seeing him again and found an excuse not to go. I phoned him at home when I knew he would not be there and left a message.

"Thanks for the invitation. Although not confirmed, I think I will be in Utah visiting Alan's niece. Anyway, you seem to be in a needy place and it makes me uneasy. Not sure I really want to date anyway."

Not to be outdone, I guess, Ralph responded by voice mail.

"I don't see myself as needy. Perhaps you will be ready to date someday. Best wishes."

Spirited fellow, aren't you?

Confiding in a friend, I admitted how thrown off balance I was with the coincidence. She recommended that I try at least three dates with him before making a final decision. Nerves can make people act strange, but by the third date, they usually let down some.

One week later, after giving it much thought, I telephoned Ralph. Explaining myself, I told him that the coincidence had frightened me. There are nearly three million people in the Denver metropolitan area, and I meet the owner of the "bad investment" townhouse? What were the chances?

Then I asked if we could just have some fun and get to know each other. Sure. Fine. He would get back to me. And he did. A couple of days later, he asked if I would I like to join the small prayer group that met at his home on Sunday nights.

"No, I want to get to know you first."

Another phone conversation and we decided on dinner and a movie. In an effort to avoid any awkward moments, I devised a list of possible discussion topics, planning to keep the list in the back of my mind for reference. On our date, I admitted to having made the list.

We returned to my house for tea after the movie and Ralph asked to see the list I'd mentioned. The "dating interview" resulted in some laughs. I held the list of questions close to my chest as I saw him to the door and said good night.

No, I'm not ready for a hug from you. No way. Can't let you in.

For our third date, I offered to take him to dinner for his birthday. As the day approached, I absolutely dreaded it and almost cancelled.

Guess I can get through one more date, but that's it. Done. Vamoose!

Curiously, the conversation seemed much more relaxed as we stood in my garage after we returned from dinner. I had not planned to invite him in, but he suddenly seemed more interesting to me and the garage was chilly.

Two hours later, as he was preparing to leave, he caught me up in an enormously wonderful embrace, a major bear hug.

This feels good.

Another hug and he turned to leave. Instead, though, I tapped him on the shoulder and asked for one more.

"Thanks, I needed that," I admitted, after receiving my hug.

Alan, how I've missed you!

We continued to see each other over the next few weeks. I liked the attention, including the e-mail messages and phone calls. He was affectionate. It was easy to get caught up in the physical feelings, but I kept my head on straight.

While Ralph was quickly getting serious, I wasn't. He told me he loved me.

How could you possibly love me already? It's only been a few weeks! It was almost a year before Alan told me he loved me and when he did, I knew he meant it.

Ralph talked about getting married. He had married his first wife two months after they had met.

I don't even know you! Alan and I knew one another nearly two years before he proposed.

It seemed as if Ralph was looking for someone— anyone—to slide in and take over from where his wife had left off.

There were other underlying issues that needed to be separated from the affection and addressed: interests and lifestyle. While we shared a broad interest in music, it seemed we had little else in common. Ralph enjoyed downhill skiing and golf. I preferred snowshoeing, hiking and bicycling.

In addition, Ralph was deeply immersed in his fundamentalist church, a lifestyle I had left years earlier.

Been there, done that.

Organized religion held no appeal to me, at least not to the extent that my life would be limited by the church. Stepping away from that box had broadened and deepened my belief in God. I now belonged to the "big" church of all believers: God's church.

The affection would not sustain us. It could not

mask the real-life challenges. A healthy relationship requires much more than that. I knew that I did not want to continue seeing Ralph.

During our final conversation, he mentioned that there were more women than men in our age group.

Is that a threat? I would rather be alone than with the wrong man.

For the third time since our meeting, Ralph also said his goal was to marry a rich widow and live the life to which he would like to become accustomed.

"Good luck with that."

Once we ended the relationship, I missed the attention, but I knew I had made the right choice. Within four months, Ralph had found the woman of his dreams and had married her.

What was that relationship all about?

I had wondered, at first, if Ralph and I were somehow destined to know one another because he had purchased the "bad investment" property. Instead, it seemed that coincidence had been brought to my attention by Alan as his way of telling me that a relationship with Ralph would be a bad investment for me.

Alan still watching over me.

CHAPTER 24

Selling the House

The news of Mark and Sarah's engagement in October 2002 was bittersweet for me. As happy as I was for them and Mitchel, I would be facing yet another loss. They would be moving 1,600 miles away to Syracuse, New York.

I can't possibly live in this house alone. No Alan. No Sarah. No Mitchel. Emptiness.

Fearful, I began to think about selling the house, timing it so I would be out of the house soon after their wedding. I wanted to run away from the pain.

One day, Jim, a bank customer and friend, stopped in my office to visit. He was a real estate investor I admired and saw as a mentor. Jim and his wife were selling their townhouse. It was in a nice North Boulder neighborhood and backed up to open space.

Sharing the news about Sarah, I told him my tentative plans to move. Next thing I knew, I was viewing his property.

I could live here. I can escape to this place.

The "experts" say one should avoid making a major, life-altering decision—a move, a marital change, a job shift—for at least one year after the death of a loved one. I was operating from a place of fear and confusion, unaware of my own instability and incapacity to make a clearheaded decision.

After viewing the townhouse twice, I was definitely interested. Upon the third viewing, Jim arranged to show me other listed properties in the neighborhood. He would act as a transaction-broker and we would strike the deal at his kitchen table. Though I was fully prepared to write the earnest check, I began to feel uncertain about the purchase as I drove to his house.

Is this right for me?

As I approached the right turn into Jim's cul-de-sac, a rider on a Harley came out of the cul-de-sac, turning left and crossing my path.

Alan?

Jim and I sat at his kitchen table, drinking tea and visiting, for more than two hours. We discussed the idea of my buying the townhouse then, and he and his wife would rent it back from me until May 2003. Jim suggested I put my home on the market in March.

Then a torrent of questions hit me.

How will my house show with Sarah packing for her move? And with the stress of planning the wedding, do

I want to add the stress of showing the house? The real estate market is soft. What if my place doesn't sell? I could end up supporting two homes.

Disappointing Jim, I left saying I would have to give it more thought and I would let him know my decision within the next three days. Driving away, I already knew.

This transaction is not going to happen. What am I running from, anyway? Memories?

I decided to embrace the memories and chose not to put my house on the market until one year after Sarah's wedding. Still, during that year, I avoided using some areas of my home because they were attached to special memories of Alan. One of those areas was the hot tub in the atrium attached to the south side of the house. For three months prior to the accident, Alan had worked on reconstructing the frame to accommodate a new six-person tub, replacing the twenty-year-old smaller version. He had completed the installation two weeks before his death.

I don't want to use it, not without Alan.

Neither did I use the fire pit on the patio. Alan had been particularly fond of the fire pit. He had frequently built a fire and enjoyed sitting by it, year-round. I regretted that I had not weathered the cold, cuddled up in a blanket, and remained there on those nights he had asked me to stay longer by the fire with him.

I did find peace in the house, alone, during that year. However, it provided far too much space for one person. Besides, I had to drive through that fatal intersection too often. Once the house was sold, I planned to put my furniture in storage and move to my condo in the mountains.

I'll try living up there for one year.

I had avoided clearing the closet and Alan's dresser of his personal effects, as if he might miraculously return. One day, more than two years after his passing, I was sorting through my clothing, making stacks of things to donate to a charitable organization. Without thinking, I began to mechanically pull Alan's clothes from the hangers, too.

Ten large plastic bags later, I called Beth at work.

"I did it. No plans to do it, but I did it. It doesn't feel good and it doesn't feel bad. It's done."

Continuing to prepare the house for sale was a slow, emotionally draining process. Staying focused and on track to list the house by May 1, 2004, my heart lagged far behind. No one was making me do it, but it seemed like the right thing to do. I was no longer enjoying the house. Someone else would.

Mark had sorted through Alan's tools in the basement

and had taken several items with him when he and Sarah moved to New York. Paul came to help me sort through things in the garage and basement. Somehow, I got through the preparation process, clearing drawers, cupboards and closets.

On May 1, 2004, the house was listed. There were two or three showings each week through June. Then the market began to slow down. As the ninety-day listing period was coming to an end, I called my real estate broker, Darrin, and suggested we drop the price. Tearful, I signed the amendment and a ninety-day extension. The tears came not because of the reduction in price, but because of my own sadness.

The house may really sell after all.

The price reduction made no difference in the amount of activity. The market remained sluggish throughout the summer. If the house was not under contract by the end of October, I planned to wait until the following spring to try selling it again.

Meanwhile, I met a few women friends in the mountains during my weekend trips to the cabin. One of the ladies, Shawna, practiced Feng Shui, the Chinese art of arranging space. She had shared with me some success stories related to selling homes.

Maybe I should try this technique.

Shawna and two other friends came to my home on a Monday and Shawna gave me tips on rearranging

some household items to enhance activity near the front door. I admitted that I didn't really want to sell the house because of my attachment to the memories there, but I was *willing* to sell it. Compassionate and insightful, they prayed with me for a satisfactory outcome.

Perhaps someone will see what Alan and I saw in this house and there will be love here again.

The very next day, Darrin called and asked whether I would consider leasing my home. A retired professor, moving to Colorado from London, was looking to rent for one year. Darrin had driven him by my house and he wanted to see it. Darrin asked me to make a list of criteria for renting it, but only if I was interested in this proposition.

Wednesday, as I was leaving to visit Alan's niece in Utah, I dropped off my list at Darrin's office. I would need $2,100 each month to cover my expenses. Darrin confessed that he had already quoted $1,750 monthly rent without my input.

*What's that about? Is he really looking out for **my** best interest?*

As I drove away, I called Darrin from my cell phone and told him that I was not interested in renting my home after all.

On both Thursday and Friday, Darrin left messages asking me to reconsider. The Londoner was really interested. Darrin had shown him the home and the

gentleman wanted to meet with me on Saturday afternoon. Would I agree to that?

He's sure persistent. Perhaps I should look at this offer. Leasing the house for one year will give me the opportunity to try living in the mountains.

Darrin and the Londoner planned to arrive at 4:00 p.m. on Saturday. That morning, I was a sentimental wreck. I burst into uncontrollable sobs when Paul called. I told him there was a strong possibility that I would be moving out of the house soon.

At 1:15 p.m., Darrin's office assistant called to inform me of a showing between 1:30 and 2:00 p.m. A young couple, David and Michelle, wanted to see the house.

While I knew that it was usually best to leave the property during a showing, I was expecting an important call.

Short notice. I'll just stay out of their way.

The couple and their broker arrived at 1:30 p.m. I greeted them at the front door and offered an apology for my tear-stained face. "I'm emotional about leaving this house, the home I shared with my deceased husband. Someone is coming at 4:00 p.m. to sign a rental lease. If you are interested, you will have to make an offer before 4:00 p.m."

Then I retreated to my office.

Less than ten minutes later, the broker came to me and said, "David and Michelle love the house and they

want to buy it. They are willing to rent it from you until they sell David's home in Austin, Texas. In fact, they are getting married in early November and would like to move in by mid-October. I'll call your broker."

At 3:30 p.m., Darrin's assistant called again, advising me of yet another showing between 4:00 and 5:00 p.m.

Talk about activity!

Though not enthralled with the hot tub, the Londoner was definitely interested in the house. He found it warm and inviting, unlike the newer models on the market. Darrin and I asked if he could wait twenty-four hours. An offer to buy the house was coming through and I needed to consider that before making a final decision about leasing.

The Londoner and I stepped outdoors to walk around the yard.

"Darrin misrepresented me on the rent," I said. "I will need a minimum of $2,100 per month."

No problem.

The final showing was for a five-member family. It took place around 4:30 p.m., adding to the flurry of activity in the house. Darrin advised the other broker of the pending lease agreement and the offer that was forthcoming. Without fanfare, the others departed.

That night I tossed and turned, attempting to find sleep.

What should I do? If I rent the house for one year, I'll

be trying to sell it again next year. Will the market be any different? My original intention was to sell the house. Alan, what do you want for this house?

I could practically hear his voice, "Love. Love is the answer."

David and Michelle had been friends for thirteen years, staying in touch from different states over that period of time. Michelle had married and had a daughter, then got divorced.

A single mom and a young child—just like Sarah and Mitchel.

Love between David and Michelle had blossomed when they saw each other again after several years.

They will be newlyweds in the house where Alan and I started our life together as newlyweds. There will be a young child in the home and possibly more. David and Michelle love the house. They will enjoy the hot tub, too.

I decided to sell the house to David and Michelle.

A week later, while driving to lunch with a friend, a vaguely familiar telephone number appeared on my cell phone as it rang.

Jodi!

"Hi, Jodi! It's been forever!"

Immediately, she said, "You sold your house."

How did she know?

With an emerging thought, I proclaimed, "You're the mortgage broker!"

Jodi explained that her friend was the real estate broker for David and Michelle. She had referred them for the mortgage, and Jodi met with them to take the application. She went on to say that David and Michelle were well-qualified for their loan and they were really, really excited about the house.

Jodi had told them how fortunate they were to be buying my home.

"There has been a lot of love in that house," she had said. "A great love between Alan and Doris. Love for Doris' daughter, Sarah, and her son, Mitchel, too. The house is full of wonderful, loving memories. It has good karma."

My face was wet with tears. Of all the mortgage brokers doing business in the Denver-Boulder metropolitan area, Jodi would be handling the transaction.

Signs. So many signs. A sign that I had made the right decision in selling the house to David and Michelle. A sign, too, that the mortgage transaction was in the capable hands of a businesswoman and friend I trusted and admired. And, finally, a sign that selling the house was the right thing for me to do.

David and Michelle moved into the house that October. I placed my furniture in storage and moved to the mountains, to the cabin in the woods.

The house was in good hands, I was sure of it. And I still had my memories, held in my heart forever.

CHAPTER 25

A Dream Come True for Sarah

I was not the only one to receive signs from Alan. Sarah did, too. She and Alan had forged a close relationship during the time that she and Mitchel lived with us and that relationship continued after his death.

In August 2004, after reading *You Can Heal Your Life* by Louise Hay, Sarah felt inspired to write a list of affirmations. Among them was her desire to act on stage. Although she had never expressed this secret dream from early childhood to me or other family members, we all knew it innately. She was quite the little actress while growing up.

A few weeks after she wrote the affirmations, she saw an opportunity to audition for the lead role of Sarah Norman in a Syracuse community theater presentation of *Children of a Lesser God*—a perfect match for her signing skills. While the part did not require previous acting experience, the director chose a deaf woman who had experience. But when her attendance at practice was

inconsistent, the director called Sarah and offered her the part. Sarah joyfully accepted.

The play was slated to open in early December 2004. I felt Alan's presence on opening week, as if he were somehow involved. He would have been proud of her achievement.

Sarah felt Alan's spirit, too.

A couple of days before opening night, Sarah called me, crying. She declared, "Mom, you won't believe what happened! Luke (born to Sarah and Mark six months earlier) recently started leaning back in his swing chair and putting his hands behind his head with his elbows jutting out on both sides. I didn't think that much about it. Until today. I was watching television and I could see him out of the corner of my eye. He cleared his throat to get my attention and, in slow motion, he leaned back, raised his hands, interlocked his fingers and placed them behind his head, elbows out—just like Alan used to do! His eyes were locked onto mine and he had a big grin on his face! Mom, it felt as if Alan were saying, 'Are you paying attention?'"

Could this be true?

One evening, as the cast sat behind stage waiting for the play to begin, the lady who played Sarah's on-stage mom shared a mysterious occurrence in her home. That day, before coming to the theater, she had noticed that her liquid soap dispensers were dripping.

Naturally, she rationalized the mystery, saying it must have been a result of the changing weather or something like that.

A chill ran up and down Sarah's spine. After experiencing the dripping soap dispensers at our home in Colorado, she recognized it as a sign—another sign from Alan.

There you are, Alan, supporting Sarah in this new endeavor.

When the annual Syracuse Area Live Theater (SALT) award nominations for community theater were posted in the Syracuse newspapers, *Children of a Lesser God* was slotted in four categories: Play of the Year, Best Director, Best Actor and, yes, Best Actress. The play was awarded as Play of the Year and for Best Director. Sarah did not win in the Best Actress category but felt honored to have been nominated for her first acting job.

A dream come true—blessed by Alan.

CHAPTER 26

My Rings

Alan had been pleased to offer me the one-carat, classic round cut engagement ring. The diamond was set on a slim, yellow-gold band. While diamonds and other material things are not high on my list of important things in life, I was touched and honored by his thoughtfulness and generosity. It was beautiful.

At the time, I had been wearing my mother's wedding ring on my right ring finger. It, too, was a slim, yellow-gold band. Mom wore the ring nearly forty-seven years, until she passed away in 1992. She never took the ring off, even when her hands became swollen with arthritis in her later years.

As a child, I remembered her hardworking hands, canning fruits and vegetables, cooking and baking, cleaning, sewing, ironing and gardening. For some reason, my most vivid memories included her hands, covered in flour, as she happily rolled pie crust or kneaded bread dough.

After Mom passed away, my father allowed me to keep her wedding ring—a priceless remembrance. Alan knew how much the ring meant to me. After he proposed, he said he was willing to purchase a matching wedding band to wear with my engagement ring but wondered if I might want to wear my mother's ring as my own. It was a thoughtful suggestion and that is exactly what I did.

Throughout the years we were married, my fingers would often swell near the end of the day, especially in warm weather. When I got home from work, I would slip off my rings and set them near my sink in the master bathroom. It became a daily habit, whether or not my fingers were swollen.

A few weeks before Alan's accident, my friend, Judy, and I met in Denver for an evening movie. During the movie, I began to slip my rings on and off as they became uncomfortable.

I could put them in my jeans' pocket. No, I may forget about them. I know! I'll slip them on my key ring where they will be safe.

After the movie, Judy and I said good-night. It was late and we both had to work the following morning. When I arrived home, I put my keys on the kitchen counter. Eager to climb the stairs and crawl under the covers, I totally forgot to retrieve my rings.

As I was leaving for work the following morning, I

grabbed my keys and slipped my rings off the key ring and onto my finger. Alan was sitting in his office at the computer. On my way out of the house, I stopped to give him a kiss good-bye.

Surprisingly, he stood up and followed me into the garage, all the while expressing his unhappiness with me for being so cavalier about my wedding rings.

"Did you go out after the movie with Judy?" he asked. "Were you pretending you weren't married? Judy is single. You are not."

Feeling sheepish, I softly chuckled to myself.

How sweet that he cares so much.

Offering an explanation, I told him my fingers had swollen and I had slipped my rings off in the movie theater. The key ring seemed a safe place to put them. I didn't want to forget them in my pocket.

His final words on the subject were, "If they're too small, get them sized!"

I stopped wearing the rings about two years after Alan died. Until that time, I continued to take them off every night. As many as five years later, an impression from the rings remained embedded on my finger.

Alan holding on.

CHAPTER 27

Rainbows

The rainbows created by sunlight bouncing off my diamond ring in the limo on the day of the funeral were the first of many signs of Alan in the form of rainbows. Since then, other rainbows have mysteriously materialized—silent messages of love and solace from Alan, signaling, *I'm still here, Honey. I'm still here.*

After the funeral, my niece and nephew from Illinois transported several floral arrangements from the mortuary to the accident site. As they were placing the pots, a lady exited her car and approached them. She introduced herself as Linda and explained that she had heard the crash of the accident from her house, which backed up to the fateful intersection.

Linda told them that she had scaled her backyard fence, arriving at the accident scene to find Alan trapped under the vehicle that had hit him. Linda added that she was a nurse and, without hesitation, she had crawled under the vehicle and had attempted to

keep Alan conscious until paramedics arrived.

Before leaving, Linda wrote her name and phone number on a scrap of paper and said she would be willing to talk to me if I ever wanted to speak with her personally.

It was four weeks after the accident when I contacted her. Having returned to work earlier that week, I collapsed in despair on Wednesday night and missed work Thursday and Friday. My shattered heart was heavy with grief and denial.

Alan, you aren't really gone. This is just a horrible, horrible nightmare. You are going to come home any day now. I just know it!

I wondered if I would accept Alan's death if I faced the facts surrounding the accident. Friday morning, I read the copy of the accident report that we had received from the Westminster Police Department. Then I called Linda and asked if I could visit her. True to her word, she agreed.

When I pulled into her driveway, I remained in the car for a few minutes.

Why am I here, really? What do I expect? Should I hear what this woman experienced in Alan's last moments?

Reluctant, I stepped out of the car and walked toward the house. As I approached the front door, my attention was drawn to a six-inch rainbow resting on the glass storm door.

Peace. No harm will come to me here.

My tears flowed automatically and uncontrollably as Linda shared what had happened at the accident site. When she first asked his name, Alan had moaned in pain. In response to her asking a second time, he barely uttered, "I can't breathe."

Linda encouraged him to hold on but in a matter of minutes, he fell unconscious as the paramedics arrived and placed him on the board.

While I did not necessarily feel any worse or any better, it was reassuring to know Alan did not suffer long . . . and that he had not died alone.

As the months wore on, awe inspiring rainbows emerged everywhere: on the table while I dined with my good friend, Donna; on the living room mirror at the cabin; on the garage floor just after I listed my house for sale; on the dirty windshield of my car; and on the living room wall of Beth's house from sunlight reflecting through the peephole on her front door.

In April 2005, a rainbow appeared on the interior wall near my seat on an aircraft landing at Washington Dulles Airport. The stop was a layover on my trip to visit Sarah and her family in Syracuse.

Alan promising a safe trip.

Alan even left signs, including a rainbow, when I went on a blind date a couple of months after that trip. The night before we were to meet in Idaho Springs for

lunch, we exchanged cell phone numbers. His number ended with 2236—the personal identification number Alan used for everything.

I had written the number on a piece of paper and, as I pulled into a parking space across the street from the restaurant, I glanced at it, lying on the passenger seat. A rainbow had cast itself across the number.

Thanks for coming along.

While these sightings offer comfort, there isn't always a specific connection that comes to mind. However, for me, each rainbow serves as a meaningful sign that Alan is still with me.

CHAPTER 28

Electrical Signals

The combined master bedroom and master bath in our home formed a large L-shaped, open room. After the accident, I began sleeping on Alan's side of the bed in an attempt to feel closer to him, to recapture his scent, and to minimize the emptiness there. Fearful of feeling desperately alone, the light over the glassed-in shower served me well as a night light.

A few nights after the accident, I was fortunate to have a bit of respite from the emptiness of that bed. My friend, Jill, had flown in for the funeral and slept with me. As I was beginning to become accustomed to doing, I turned on the shower light and crawled into bed next to her. We held hands and talked into the early hours of the morning. I told her all about my life with Alan and about some of the coincidences that had already occurred. She wasn't sure she believed they were signs from Alan.

Then, restless, I drifted into short periods of sleep.

The shower light burned brightly . . . and then it went out. I lay wide-eyed on the bed, incapacitated.

What was that?

I awakened Jill and she lay there in awe, too.

Is this a sign for Jill's benefit?

Throughout the night, the light alternated between on and off. Unable to sleep, I watched the clock at the head of the bed for a pattern but found none. On twelve minutes, off fifteen minutes. On seventeen minutes, off thirteen minutes. On fourteen minutes, off eleven minutes.

I described the experience to Jamee at daybreak. Doubting me, she smiled wryly and rolled her eyes. At just that moment, the light switched on and Jamee practically jumped out of her skin. That light continued to switch on and off for as long as I lived in the house.

Electrical signs have appeared periodically since that night with Jill.

One sign involved the garage door keypad code. Several months after the accident, one of Sarah's girlfriends asked if her husband could work on his car in our garage. I was out of town and Sarah would not be home that day. Despite knowing that he was less than up-standing, she gave out the garage door keypad code anyway. That night, after her friend's husband had been there, the keypad stopped working.

Alan protecting us!

Twice there were instances when a tape recorder malfunctioned. The first happened when the staff at the mortuary attempted to tape the funeral service for Alan's mother, who could not attend. The tape ended up garbled and, ultimately, ineffective. The second occurred when a clairvoyant taped our meeting. When she went to take the tape out of the recorder at the end of the session, she noticed that the machine had not been recording.

Alan.

One of the most dramatic incidents happened in late August 2003. At that time, I knew I needed to get to the work of reconciling Alan's company's books for the 2002 tax year. We had never filed our tax returns late, but I was late that year and the extension deadline was fast approaching. It was time to stop putting it off.

Alan had kept his QuickBooks account password protected. A couple of weeks before his accident, he mentioned that he had changed the password. Unfortunately, I wasn't really listening.

I won't need it.

After attempting to break the password earlier in the year, I had contacted QuickBooks. The technician had told me I would have to purchase an updated version and download the old file to the new version before he could assist me.

I really don't want to do the taxes, anyway.

It was highly unlikely that I would use QuickBooks again, so I chose to manually recreate that first quarter of business from his bank statements. Alan died at the end of the first quarter and the employees had all been paid through March 28, 2002, leaving the business records in perfect order.

Was this part of the master plan, too?

Under the stress of meeting the extension deadline, I forced myself to sit down with all the paperwork one Saturday. Although it was difficult to concentrate at times, I worked nine hours straight, determined to complete the task of compiling everything for the accountant.

It was close to 1:00 a.m. when I gathered up the organized stacks of paperwork, feeling a great sense of relief and accomplishment. Exhausted, I was anxious to slide between the sheets into the welcoming bed. As I stepped from the kitchen to climb the stairs, the electricity flickered on and off, on and off. The microwave beeped, on and off. Music from the stereo switched off, then on again.

Too tired to care, I continued up the stairs to the bedroom. Throughout the night, the lights, ceiling fan, attic fan, stereo and microwave periodically flickered and beeped, on and off, as I drifted in and out of sleep.

The front doorbell rang at 8:00 a.m. the next morning. Opening the door, I was greeted by public service

technicians. The next-door neighbors had called in a complaint about electrical problems. Could they please have access to my backyard?

Once I was fully alert, the electrical activity from the night before started to make sense.

Alan, celebrating my completion of the taxes.

Perhaps one of the most touching—and haunting—electrical signs happened after Beth applied for a job at a bank. Until that time, she had been working at the same community bank where I had been employed. The new job offer came through with the condition that neither the credit check nor the background check eliminated her. Beth was concerned about earlier problems with her credit.

I was at the cabin with a friend when Beth called to tell me the bank wanted an explanation for the previous credit problems. I helped her put it into words. As I was telling my friend that I hoped Beth would get the new job, which would mean a promotion to management and a significant raise, I sent up a mental message to Alan.

Please help Beth get this job.

About an hour later, Beth called with the good news: she had been cleared for the job and had accepted the offer. After her call, I set the portable handset near the Bose radio/CD player on the kitchen counter. As I walked away, music started to play.

That's odd.

Shortly thereafter, I moved across the room to increase the volume, which seemed to be fading. I pushed the volume arrow several times, but the music faded into silence. In an instant, I checked the CD to see what song had been playing. It was Sade's "By Your Side."

Alan by my side.

CHAPTER 29

Other Signs of Alan

Many other coincidences have occurred that have comforted me and have assured me that Alan is still here. Some have been simple. For example, Alan loved pistachio nuts. Once, while visiting his gravesite, I noticed several pistachio nut shells lying scattered on the ground near the grave marker, a stone bench.

Other coincidences have been more involved.

Three months after the accident, I began feeling the need to talk to Sharon, the therapist Alan and I had used. However, Sharon was not covered under my medical insurance policy with the bank. Starting over with another therapist was unappealing. Besides, I was comfortable with Sharon. Alan and I had a history with her. I would have to figure out a way to pay for the sessions.

I'm going. Period.

I made an appointment to see her.

The following day, I received a letter from the Adams

County Crime Victim Compensation Board. The letter granted a $2,100 stipend to be used toward grief counseling and post-traumatic stress disorder therapy. The grant named me, Sarah and Mitchel—all members of our household, all victims of the trauma surrounding the accident.

You really are looking out for us, aren't you?

After Sarah's wedding, I kept Mitchel and my other grandson, Devin, for a two-week visit in the mountains. At the end of the two weeks, I was to deliver Mitchel to his new home in Syracuse, New York. This was part of a plan to give Sarah and Mark some time alone together.

After honeymooning for two nights at a resort in the foothills near Boulder, they went to the house to load the U-Haul truck they had rented. They planned to be on the road by mid-afternoon on Monday.

There were some obstacles, though. First, the truck that Mark had reserved was not at the pickup site. It would be three hours before the truck was made available. Then the spare key to my Audi did not work, so they were unable to move it out of the garage, forcing them to work around it.

Once the truck was packed and Sarah's car was

loaded on the trailer, she and Mark piled into the truck cab ready to depart. However, the engine would not turn over. The dome light had been left on and had caused the battery to run low.

It was after 8:00 p.m. when they hit the road, heading east to their new home, to their new life as husband and wife.

You were making things difficult, weren't you, Alan? You didn't want them to leave. Neither did I.

CHAPTER 30

A Good Wife

Although I regularly expressed my love and appreciation to Alan, a few lingering questions had continued to pervade my thoughts more than three years after the accident.

Did Alan know how deeply I loved him? Was I a good wife?

Little did I know that I would one day get the answers to those questions.

In June 2005, I visited a naturopath in Breckenridge, after having met her one evening at a seminar on nutrition. Dr. Nancy had studied both Eastern and Western medicine, choosing to practice the former. In her holistic approach, she conducted an extensive interview and a thorough physical examination at my first appointment.

During the interview, I told her about the stresses I had experienced in my life and that I had made a concerted effort to reduce my level of stress by leaving my

corporate job. I also explained that I had lost my husband three years earlier. I expressed my profound love for him and my appreciation for his love, adding, "He was so good to me, a gift, really."

Out of nowhere, she said, "Your love was a gift to him, as well."

How would you know? You don't know me, let alone Alan.

She told me she did not promote her spiritual gifts, but that thoughts often came to her during an interview that she felt compelled to share with her clients. She had promised God she would not ignore these strong feelings.

"Alan is here in the room," she said, "and he wants you to know that your unconditional love for him was a gift. He says you gave him more than he gave you and that you were a good wife to him. Also, he says his only regret in leaving so quickly is that he didn't get a chance to tell you these things."

Reduced to tears, I shared—for the first time—the secret doubts I had continued to harbor since his passing.

"I needed to hear this," I admitted.

Thank you for the privilege of allowing me to love you, Alan.

There was more.

"Doris, you will be on this earth for many more

years, and Alan wants you to love again," Dr. Nancy added. "He will guide you in finding that love."

I know. I've seen the signs.

CHAPTER 31

Letting Go

Living in the mountains was difficult for me. I'm not into skiing, so the winter seemed especially long and harsh. Trying to manage my rental properties from afar was challenging, too. Admittedly, I had done little to make the condo my permanent home. My heart wasn't in it. I felt alone and isolated from life.

At the same time, I learned to appreciate being alone, something I had desired for many years while raising my kids.

If only I could soak in the tub for one hour without interruption.

After having pushed myself to succeed in the corporate world and to raise my kids, I was learning that I could just be. I also discovered that I liked my own company.

However, it seemed as though I had been running away—away from the pain of my losses. I had experienced several life-altering changes in three short years.

Alan had died. Dad had passed away later that same year. I had left my job and was living the life of a retiree. Sarah had gotten married and my home had become an empty nest. Then I sold my home and moved to the mountains. My world was no longer defining me.

Who am I?

After three months in the mountains, I had already decided I would move back to the Denver-Boulder metropolitan area within the year.

I want to live again.

The lease would end on one of my properties in Boulder in August 2005, so I sent a letter to the tenants stating that I was unwilling to renew their lease. They had plans to move east, so it worked out for everyone.

I made a few improvements to the property in Boulder and moved into it that September. I kept the condo—my cabin in the mountains—for another nine months, but I avoided staying there. Once every seven to ten days, I drove up to the mountains to get my mail and to check on the condo. More often than not, I returned to Boulder the same day.

It seemed frivolous to keep making the mortgage payments when I was no longer using the condo. It was too nice and too personal to make into a rental property. When I decided to put it on the market in June 2006, I had a full-price offer within forty-eight hours. The buyers gave me seven hours to accept or reject the

offer, so I accepted it. The next day, I panicked and was overcome with seller's remorse. I held a sentimental attachment to that condo. Alan had led me there.

What was I thinking?

Perhaps the cabin had served its purpose. It had been my healing place.

When I moved to Boulder, I thought my life would take off. I knew a lot of people in Boulder, but my connections were through my job at the bank. I was not bumping into many of these people after all. I hit a wall. Ironically, I still felt isolated and lonely living in the city of Boulder with a population of more than 100,000. I discovered that I was apathetic about my future. I was stuck.

I'm just going through the motions.

I had heard about a grief support group at hospice shortly after Alan passed away, but had not thought I needed it.

I'm too private.

Now I thought I could possibly benefit from it.

By the end of the eight-week session, I had begun to see my future, a life I was already carving out for myself. I learned that I had not had an opportunity to say good-bye to Alan. Others who had loved ones with a terminal prognosis had had time, though it was still extremely difficult. This apparently provided some level of closure. I used to think I would not want to say good-bye. In that group, I found the value in it.

About halfway through the sessions, it seemed I could hear Alan say, "I know you're going to be okay. You're the only one who doesn't believe it. I can continue to hang around and watch over you, but I have other important work to do up here. Perhaps it's time you let go."

Around that time, a friend sent me a quote, author unknown: "If you have been grasping onto something, try to let it go. Your empty hands will be ready to receive a new gift."

As the support group sessions came to an end, I found myself being more optimistic than I had been in many years.

I'm going to be all right. Guess I won't need you to take care of me forever.

Unbeknownst to me, there was another situation that I needed to let go of in this healing process. It had to do with Joshua, the young man involved in the accident that caused Alan's death.

In March 2006, it seemed Alan was tapping me on the shoulder and saying, "You need to let Joshua go. Let him know that you forgive him, and release him from the remaining balance due on that judgment."

Though I had often found myself telling others that I held no anger or bitterness toward Joshua, I had not thought about telling Joshua himself. It made perfect

sense to follow through with this. The money was not important to me. By releasing the judgment against him, Joshua would have tangible evidence of my forgiveness.

I sent a letter to Joshua suggesting a face-to-face meeting with my therapist, Sharon, or his—assuming he had one—and with his parents, if he elected to include them. I did not tell him about my plans to release him from the judgment. I simply expressed my desire to meet with him and potentially further the healing process for us both. I was not interested in discussing the details of the accident. Before I signed off, I gave him my e-mail address and my physical address, as well as my home telephone and my cell phone numbers.

I did not hear from Joshua nor did the letter come back undeliverable. I planned to follow through with releasing the judgment, but the summer slipped away before I got around to it. It was during the time I was attending the hospice support group sessions that it came to light for me again.

One Friday in mid-September, I spoke with a representative at the Adams County District Attorney's office and asked what steps I needed to take to get the judgment released against Joshua. I was told to send a letter stating the case number and my desire to have a Satisfaction of Judgment issued. Once in hand, I planned to send another letter to Joshua and include the Satisfaction of Judgment for his records.

On the following Monday morning, I received an e-mail message from Joshua. Although worried, he was willing to meet with me. He included the name and telephone number of his therapist. Would I please contact the therapist and set up a time to get together?

There's no way he could know about my letter to the DA's office. How's that for timing? That's right, there are no coincidences.

Joshua and I met two weeks later with both of our therapists and his girlfriend present. No parents. Prior to going into the meeting, I had prayed for wisdom.

Speak through me, God. I haven't the words.

Both therapists looked to me to take the lead. Speaking directly to Joshua, I said, "I want you to know that I forgive you and I'm sorry it took me this long to let you know it. I've told others, but I hadn't thought to tell you. I believe it was Alan's destined time to leave this earth. I don't know why you were chosen to be a part of it. Perhaps you will come to know that for yourself one day and use it for good in your life and in the lives of others. It's different for me. I have wonderful memories of Alan to hold onto. You don't. I'm sorry."

Joshua was quiet. His eyes filled with tears when I told him that he would not have to make another payment on the remaining judgment balance of approximately $8,000. I promised to send him a copy of the Satisfaction of Judgment when it was complete.

Joshua's therapist interjected on his behalf. The therapist explained that Joshua might find it difficult to understand the word "forgive" because he had not had the benefit of such in his life, especially regarding the accident.

The therapist went on to say that his own favorite times of the year are birthdays and Thanksgiving Day. He said that Joshua had received a gift that day and it was a day of thanksgiving.

The meeting lasted approximately forty-five minutes. Joshua and I embraced each other before we left. My heart was filled with compassion for him.

It is done.

Sharon called me a couple of days later to tell me that she was still thinking about the meeting with Joshua. She was touched by the manner in which I had handled myself and asked if I'd noticed that both she and Joshua's therapist had tears in their eyes.

It wasn't my doing.

Epilogue:
Alan's Legacy

The measure of a man is not, "How did he die?"
but "How did he live?" not, "What did he gain?"
but "What did he give?"
~ Anonymous

Alan began a journal the year he purchased his first personal computer, approximately two years before Nancy's death—ten years into her long, complicated illness. Shortly after Alan and I were married, I read through the journal, writings that depicted his fairly reclusive existence.

While sorting through some files a few weeks after Alan's funeral, I happened upon his journal again. This time, the gripping first paragraph leapt off the page:

> *November 23, 1988*
> *I have decided to start a diary or journal, as [brother] Howard calls it. Maybe someone in future years will wonder who Alan Richard Gray was. This might be of some assistance. Who this person in the future will be is a good guess, as I'm sure that nobody will care that I ever lived on this earth.*

Reading it then was like reading it for the first time. Little did Alan know how his selfless devotion to Nancy during her lengthy illness had touched those close to him. Neither was he aware that his life would change

dramatically and his walk on this earth would positively impact the lives of so many others.

Alan modeled the way as a husband, grandfather, friend, businessman and employer. Once, while we were dating and again when we were first married, Alan expressed his desire to be a good husband, above all else. That he was. He not only achieved that goal, he far exceeded it.

It has been said that the greatest gift a man can give his children is to love their mother. Although Alan was not the biological father of my children, they received that gift from him. In addition, Alan's commitment to and love for Mitchel helped provide the core values that will carry him beyond his formative years.

Friends and family still reminisce about Alan and how he touched their lives. They remember how the testimonials at his funeral service made them want to be better husbands, wives and friends, adding value to—and a new appreciation for—their own relationships.

Young, ambitious James worked with me at the bank. We shared a mutual respect and admiration for each other. In fact, I called him my "other" son. James and his wife Kathy welcomed their first child, Liam, in October 2003. During my meet-the-new-baby visit, James said, "Doris, I want to be a father just like Alan was to Mitchel."

Then, there is Luke Alan, born June 7, 2004 to Mark and Sarah, joining his big brother, Mitchel.

Your namesake, my dear.

Throughout the grieving process, I have read many, many books—*The Power of Now* and *A New Earth* by Eckhart Tolle, *Inspiration* by Dr. Wayne W. Dyer, *You Can Heal your Life* by Louise Hay, *The Game of Life & How to Play It* by Florence Scovel Shinn, and *Excuse Me, Your Life is Waiting* by Lynn Grabhorn, to name a few. In the pages of these books, I found comfort, wisdom and hope. I learned about the Law of Attraction, living in the moment, being mindful, and about the power that lies within each of us to influence our own lives through positive thinking. More importantly, I began to see that Alan had practiced these same concepts in his daily life—an example to me and to all who knew him.

Finally, there is this book, written from the heart, written in honor of and about that amazing man, my husband, Alan R. Gray.

Alan departed three days before the switch to daylight savings time, his favorite time of year. Conceivably, that was Alan's final gift to those of us left behind. There is hope in spring, and hope springs eternal.

Alan's legacy. What a blessing you were . . . are.

About the Author

Doris Gray was born in 1949 in Spring Valley, Illinois. She holds a Bachelor of Arts in Management from the University of Phoenix. Doris enjoyed a successful career in banking that spanned more than thirty years.

In conjunction with the sudden, tragic loss of her husband Alan in 2002, Doris discovered a new and deeply profound level of spirituality. She is convinced that the many coincidences that occurred around and after the loss of Alan were signs from him. Doris also believes that he transcended death and continues to exist in spirit form, watching over her and guiding her.

Those experiences eventually were shaped into her first book, *Signs of Alan.*

Since leaving her corporate position in 2003, Doris has found her passion not only in writing, but in volunteering. She is most passionate about issues encompassing domestic violence, sexual assault, real choices for women faced with an unexpected pregnancy, adult illiteracy, and the promotion and preservation of bluegrass music.

She has dedicated fifty percent of the net profits from the sale of *Signs of Alan* to charity.

Doris resides in Boulder, Colorado.

Visit the author's web site at www.signsofalan.com.

To purchase additional copies of
Signs of Alan,
visit www.signsofalan.com

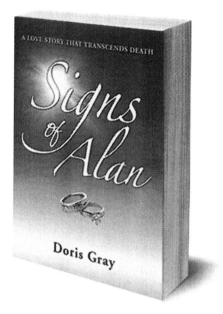

To request group sales,
book a "Meet the Author" House Party
or other types of speaking engagements,
contact:

Doris Gray
Divine Guidance Press, LLC
P.O. Box 17063
Boulder, CO 80308
303-438-5572
doris@signsofalan.com